THE ART AND CRAFT OF
WOOD
ENGRAVING

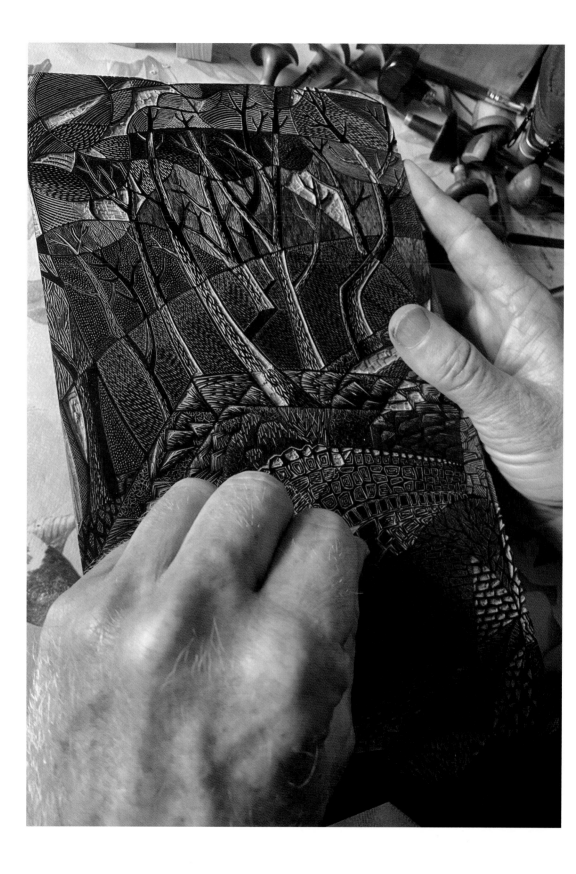

CHRIS DAUNT

THE ART AND CRAFT OF
WOOD
ENGRAVING

THE CROWOOD PRESS

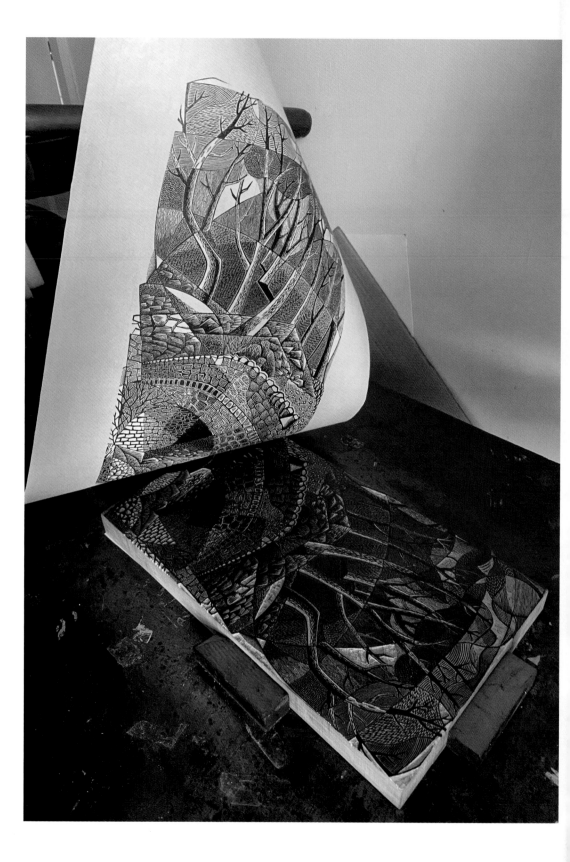

CONTENTS

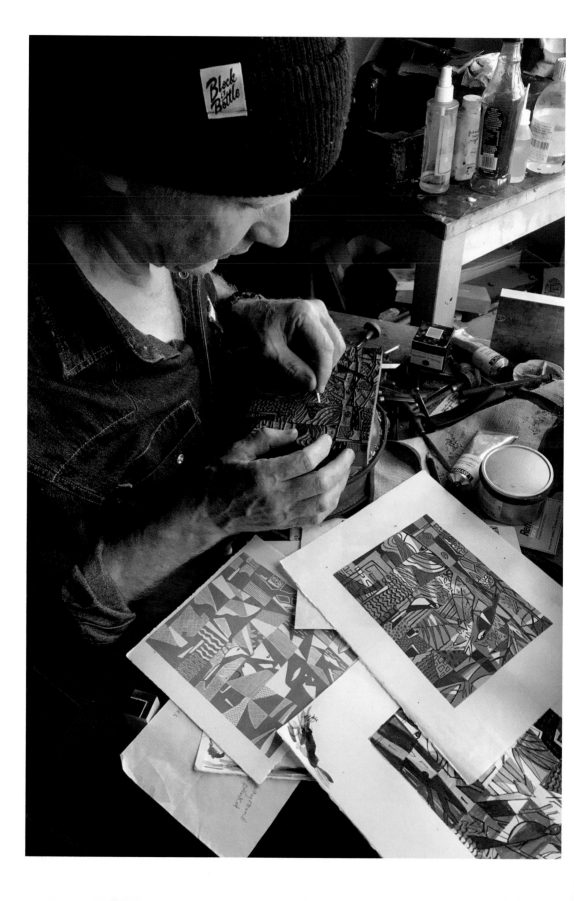

INTRODUCTION

There is a saying in the world of wood engraving, and it goes like this: 'ours is a medium where there is little to be taught and everything to be learnt.' I am sure that this is cited in relation to many other practices, but it is especially true of wood engraving. Why? Because wood engraving is, basically, refreshingly simple and no different in principle to those potato prints you made at school. It belongs to that most direct form of printmaking known as relief, and has much in common with the other forms, which are linocut and woodcut. What they all have in common is that an image or design is cut into the surface of the material and, after being rolled up with ink, a print on paper is taken. The resulting print is from the relief surface of the block. This is the opposite of the intaglio processes, such as etching, where the image comes from the incised lines. In other words, a wood engraving is a negative image, and an intaglio positive. So, it could be said with potato printing in mind that there is little to be taught here, but the subtleties and finesse of wood engraving will take you on a lifetime of learning.

This book is aimed at complete beginners but will also be of interest to anyone who engraves. I was not of that generation where wood engraving was taught in art schools and universities and, in fact, there are few engravers with that experience left. I was, however, lucky enough to have had a brief period of tuition from the great engraver of lettering, Leo Wyatt. For the most part, I am self-taught. Over the years I have absorbed a great deal of informal tuition through contact with other engravers and exposure to the world of engravings in books, exhibitions and my own collection. The Society of Wood Engravers (SWE) in the UK, and the Wood Engravers Network in the USA are precious resources of engravers and teachers who are more than happy to share their knowledge, as well as being a continuation of engraving history. The annual touring exhibition of the SWE is a unique way of discovering the best in modern engraving from artists around the world.

For those who have no experience of wood engraving, or any other form of printmaking, you will find this book a step-by-step guide to the process. The only thing I presuppose is a keen interest in the practice of drawing, since drawing is the foundation of all the graphic and plastic arts. Having said that, it could be that your first steps in wood engraving kindle a desire to advance your drawing skills. If you are already a wood engraver, the approach of another engraver will be at least a matter of curiosity and might even be of help.

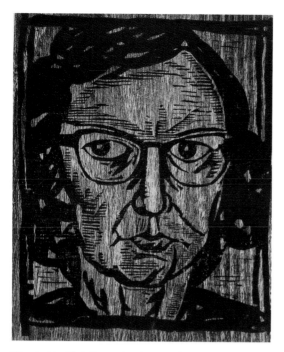

Woodcut by Chris Daunt showing woodgrain and angular cutting.

For those coming to the medium from linocut (or the less practised woodcut), you will find many of your methods are transferable. Over the years I have taught many wood engraving courses and I can usually tell if a student has linocut experience – they often tend to treat wood engraving as a smaller-scale version of linocut. I mention this now because I want to ask the question, why undertake wood engraving and not linocut or woodcut? Due to the nature of the endgrain wood block and the kind of tools used, engraving is capable of a far greater range of mark-making, texture and tonal subtlety, and to treat it as a miniature form of linocut is to miss out on a great deal.

HISTORY

Throughout the nineteenth century, writers on the subject often used the term 'woodcut'

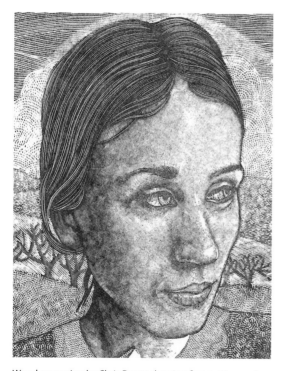

Wood engraving by Chris Daunt showing fine cutting and subtle tonality that are impossible with either woodcut or linocut.

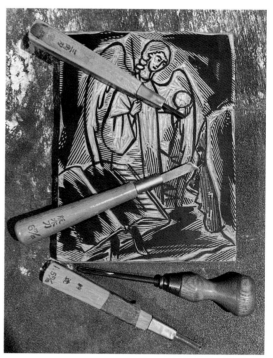

Woodcut materials: side-grain wood and woodcut tools. The knives and gouges used in woodcut are small, palm versions of tools used by carvers.

to denote both endgrain engraving as well as sidegrain woodcut. The seventeenth-century French artist Jean Michel Papillon wrote a book entitled *Traité Historique et Pratique de la Gravure en Bois*, which describes his technique clearly as woodcut. The book predates the invention of engraving on endgrain wood with metal engravers' tools, yet Papillon's practice of cutting sidegrain wood with knives and gouges is usually referred to as engraving.

The trained eye can discern the difference and it is certain that Papillon would have found

Detail from an eighteenth-century copperplate engraving. Black line crosshatching, like pen work, characterises copperplate work.

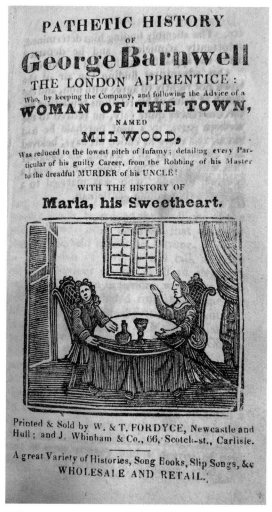

Early nineteenth-century chapbook, Newcastle. This crude woodcut style was considered inferior and unsuitable for fine printing.

engraving more suited to his quest for finesse and detail, but he never managed to make the leap that would raise his medium to the next level of refinement. With some exceptions the woodcut was long considered a poor relation to copperplate and steel engraving and was often used to illustrate the chapbook. These were short books for popular consumption, accompanied by woodcut images that often did not relate to the text, rather like the clipart image. For works of literature, copperplate was the only technique considered worthy to accompany fine prose or poetry. However, the cost of this kind of illustration was high, since the printing of an intaglio plate required the sheet with the engraving to be printed in a

THE FOX AND THE FROG.

Aesop's Fables by Elisha Kirkall. These engravings were relief prints, though there is some uncertainty as to whether Kirkall used endgrain wood or metal. Nevertheless, these illustrations were a step towards the development of wood engraving.

different press: one press for the copperplate and another for the text with moveable type. Hence, the emergence of a type of high wood block cut with the delicacy of a copperplate engraving revolutionised the printed page.

It is often assumed that Thomas Bewick (1753–1828) invented wood engraving, and the fact that a Google search implies that he did should make you wary of trusting this distinctly fallible source of information. Although it is true that Bewick is considered the father of wood engraving, he did not invent the medium. As far as I know, no one is certain who first put a graver to a block of endgrain wood, but it may have been Elisha Kirkall with his engravings for Samuel Croxall's *Fables of Aesop and Others*, first published in 1722.

As an apprentice engraver the young Thomas Bewick displayed a natural aptitude for jobs requiring wood engravings and he rapidly mastered the medium. His engravings for *A General History of Quadrupeds* (1790) and

The History of British Birds, published in two volumes (1797 and 1804), show his extraordinary talent as an engraver, as well as being the most comprehensive visual account of natural history. Bewick's engravings are remarkable for their accurate depiction of wildlife, as well as astonishing technical skill in his creation of silvery-grey tones by means of contouring his blocks before engraving, so that selected areas received less ink and less pressure in the printing process. Equally special are Bewick's vignettes or tailpieces depicting everyday life in Newcastle and his beloved Tyne Valley, with a keen and compassionate eye.

After Bewick, the industry standard for illustrations in books, newspapers and periodicals was wood engraving, and as a result engraving workshops became widespread. The wood engravings coming out of these workshops were often remarkably accomplished, but were reprographic images made to mimic pencil drawings or

Thomas Bewick, from *British Birds*, volume 1, *Land Birds*.

Illustration for *Alice in Wonderland*. Wood engraving as a facsimile medium, replicating pen and ink drawings. Extraordinary skill by the Dalziel brothers, but working against the medium.

photographic originals. As such, they were a debased form of the medium, working against its natural propensity to produce white lines from black. The well-known illustrations for Lewis Carroll's *Alice in Wonderland* (1865), drawn by Sir John Tenniel, are a good example of such engraving.

The most respected wood engravers of the age, the Dalziel brothers, were tasked with making engravings of Tenniel's pen drawings and were expected to make faithfully accurate cuts replicating every pencil line, dot and cross hatching. Technically these engravings were the high point of engraving skill (as well as a debasement of the medium) and were made as engraving was about to be replaced by the half-tone photographic plate. Printing from the relief

half-tone plate meant that the intermediary stage of producing an engraved block was all but eliminated and by the 1890s illustrations in books, journals and newspapers were mostly from photographic plates.

At its very best, nineteenth and early twentieth century reprographic or facsimile engraving can be seen in the astonishing engravings of Timothy Cole (1852–1931). English-born Cole was brought up in America and became an engraver/illustrator for art magazines. He was sent to European galleries to make engraved copies of old master paintings. Cole had the painting photographed onto the engraving block using darkroom methods and would then engrave it. These engravings are worth studying and learning from. Even though no one would consider making engraved copies of paintings today, Cole's techniques of shading and modelling are very instructive. Note how, in the example *below* there are no outlines – one shape moves gracefully into another by changes of linear direction or width of line. Such was Cole's popularity, his work was still being used well into the twentieth century and he produced signed (though unnumbered) editions of his work. These signed engravings can be seen as emblems of the transformation of wood engraving from a commercial entity to a piece of fine art.

There was, however, a period of overlap when engravings were sometimes preferred over the relatively fuzzy half-tone image. Engravings are crisp and hard-edged by comparison with the early half-tone prints found in newspapers. So, for example, clients wishing to have a catalogue of machinery or optics would usually choose to have the images engraved.

This practice continued well into the next century – especially in the United States – and there are still a few living Americans who were apprenticed trade engravers.

By the start of the twentieth century, most so-called 'trade' wood engravers were out of a job, leaving wood engraving to rise from the ashes into a medium of fine art, either employed

for the production of fine letterpress books or independent prints. In 1920 the Society of Wood Engravers was formed to exhibit the work of a new breed of engravers who were no longer just highly skilled artisans, but artists in their own right.

There is a curious phenomenon in the history of wood engraving, and that is the large number of significant women engravers in the twentieth century. In fact, many of my favourite engravers are women. As far as I know, no one has made an in-depth study of why there are so many outstanding female engravers, but one factor seems to me plausible. The period in question was one where, if a woman attended art college, her practice as an artist was often halted if she married and embarked on motherhood. She would usually have only short snippets of time to herself when she could continue her artistic development. Wood engraving lends itself very well to this constraint because it is both compact (everything can be done on a small table) and can be taken up and put down without the technical restraints of painting. We live in different times, but the convenience of this medium is one of its great advantages.

Returning to the aphorism 'little to be taught and everything to be learnt', like many such pithy sayings, it exaggerates to make a point. The 'little to be taught' will fill this book. 'Everything to be learnt' means that you must go away and learn what you have been taught for the rest of your life. The title of this book draws attention to wood engraving being as much a craft as it is an art. For more than half a century, art colleges have seriously neglected the craft element across all the art disciplines. Today you are more likely to find traditional methods taught at independent print studios and centres than in the universities. In my workshops, and in this book, much attention is given to mastering the craft element of the process, as this is what can be taught. As for the art element, a teacher can encourage creativity, help draw it out, but cannot instil it. In an essay on art in education, writing about teaching young children to draw, Eric Gill said 'As for instruction, let it be more moral than intellectual. Tell them to be careful and keep their pencils sharp. Remember they have generally got plenty of visual imagination even if we have not'.

Timothy Cole. Detail from *Fishing Boats off Yarmouth* by John Sell Cotman. Although Cole's engravings were made to reproduce paintings in nineteenth-century American magazines, they are technical treasures for engravers.

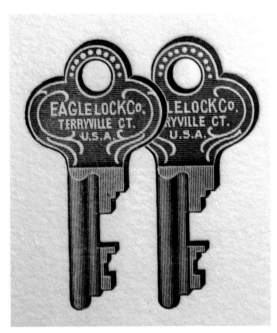

Keys. Printed from a block in the author's possession. An early American trade engraving for a locksmith's catalogue, showing hard-edged and precise engraving, often favoured over the emerging half-tone printing plate.

HOW TO USE THIS BOOK

This book takes a complete beginner through the process and assumes no previous experience with engraving tools, or any form of printmaking. I strongly recommend spending time on the sampler blocks before attempting your first engraving. After that, put your energies into composing a working drawing in which you have made all your decisions about composition and tone. The drawing stage is the time to make corrections, rub out and change your mind. Remember, a mistake remains on the block.

Each of the subject chapters – Still Life and Interiors, Landscape, Portraits and Figures, Buildings and Animals – has a breakdown of my own engravings, which takes you through the engraving in stages. Please feel free to copy these if you think it might be useful. These sample engravings are followed by further examples of my work, as well as that of other contemporary engravers. Some of the artists

who have contributed work have also provided a brief commentary on their engravings, followed by my own reflections. I am grateful to everyone who generously supplied examples for this book.

In the past it was a common first task for a student to copy an engraving as part of the learning process. Once you have worked through the sampler exercises and learned the marks that the various tools produce, it is not difficult to deconstruct engravings to figure out how they were made. Copying the work of a good engraver and even emulating his or her work for a while is not plagiarism. Do not concern yourself about being original: your unique style is something that will emerge without being forced, and imitating the work of an experienced engraver can be a step along the way. To quote Eric Gill once again: 'Look after goodness and truth and beauty will take care of itself.'

Over the past 150 years or so, many books have been written on the practice of wood engraving and I do not claim to have read them all. If I may put this book in the context of some of the other books it will allow me to justify why I have taken the approach you will find in the following pages. It stands in sharp contrast to Clare Leighton's classic *Wood-Engraving and Woodcuts*. Clare's approach, like her engravings, shows great panache but a minimum of tuition. At the other end of the timescale, Simon Brett's masterly *Wood Engraving – How to Do It*, is an indispensable handbook on the subject. I highly recommend it since it will address any issue you could have, with great thoroughness. Simon is one of the great wood engravers of the modern age. This book aims to take you through the stages in much the same way that I teach in my workshops. I hope that you will find in this book something that complements and supports tuition in another class. Besides your own practice and whatever you can learn from a tutor, your best teachers will be other engravers past and present. Art builds on art so do not feel shy to beg and borrow from masters of engraving.

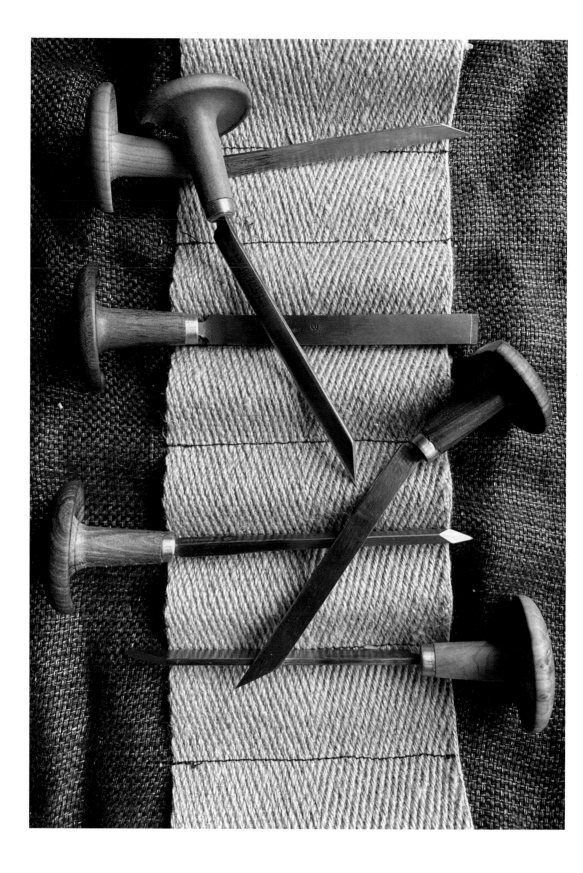

TOOLS, EQUIPMENT AND MATERIALS

To begin wood engraving, a small number of tools is sufficient and can be built on gradually to suit your requirements. Apart from the tools, generically known as gravers or burins, you will need a few other items, all of which are one-off purchases. The consumables are blocks, ink and papers.

To engrave on endgrain wood you need solid section gravers, similar to those used by metal and copperplate engravers. These are quite different to the small gouges and V tools used by wood and linocut artists. How wood engraving differs significantly from the other two is due to the tools more than the surface material

(some engravers use plastics). The marks made by gouges and V-shaped tools tend to be bolder and more graphic in character. Wood engraving is capable of the most delicate marks, tonality and texture, to a degree that would be impossible with the other two processes.

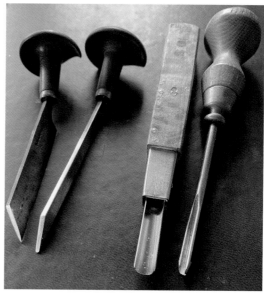

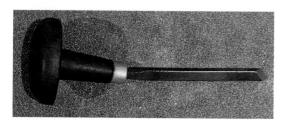

Engraving tool. The tools used in wood engraving are very similar to those used by metal engravers. For the latter work, the angle of the cutting face is steeper to provide more strength.

Left: wood engraving tools. Right: woodcut tools.

TOOLS

At the time of writing there is a small number of tool suppliers, and these are listed at the back of the book. There is also the option to buy vintage tools from wherever you can find them, though I have found this to be more difficult than it seems. Given the extent to which wood engraving was practised in the nineteenth century, it might be expected that old tools would be available in abundance, but it appears not. I have a few from the nineteenth and early twentieth centuries and I treasure them. The steel is exceptional, and the handles are often beautifully made. Old tools are usually made from a higher carbon steel, which means they

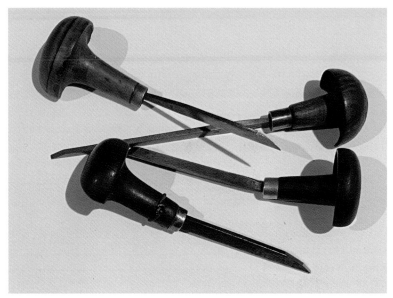

Vintage wood-engraving tools. Collected over a lifetime. Old tools are good to work with and will have a rich history.

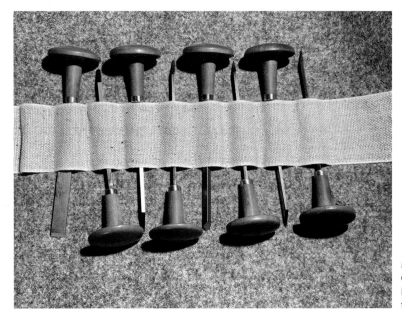

Modern engraving tools by Ian Corrigan. Hand-turned hardwood handles set at the correct angle for wood engraving.

will take a sharper edge due to a finer grain structure but are prone to discolouration and rusting. If you are lucky enough to find vintage engraving tools, do not let them slip away.

Note: Be wary of eBay sellers describing tools as vintage, when they may be no more than twenty years old. That may be the case for a pair of jeans, but you need to go back much further for true vintage engraving tools. Tools branded 'Deerness' are the best modern engraving tools.

To begin with, only buy three or four tools and work with them until you feel the need for more. When I was learning to paint, my teacher told me to use only four colours and take them to their limits, and only then add more colours to expand the palette. By starting with some essential tools, you can slowly add more to arrive at a set that perfectly suits your requirements, rather than that of someone else.

A good starter set would be:

- Medium or large spitsticker (no. 5 or no. 9).
- Medium square or lozenge graver. A very expressive tool capable of dramatic line variation (no. 2 or no. 3).
- Medium tint tool. Another versatile tool used when no line variation is required (no. 2 or no. 4).

- Medium round scorper. Essential for broader lines and clearing white areas (no. 56).

Size numbering across the makes is not uniform and the sizes above only refer to brands using Lyons or Muller steels.

Tool length

The ideal tool length is where the point of the tool extends between 1–1.5cm beyond your thumb, or forefinger. If the tool is too long it will be more difficult to gain a sense of precision in your cutting. If the tool is too short your hand might feel cramped after a period of working. That being said, my favourite tool is too short for the size of my hand, but its other qualities make up for that. Deerness Tools offer a tool shortening service.

Tool types

When you are starting out in wood engraving it can be tricky to distinguish the different tool profiles. Tools are identified by looking at their cross section. Here are the tools available to the engraver.

Spitsticker

Spitstickers have a boat-shaped cross section. This is generally regarded as the most useful tool and you will find yourself using it as a

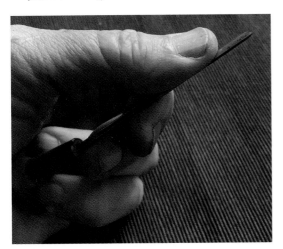

The correct tool length is not an exact science, but having a tool more or less the correct size is helpful.

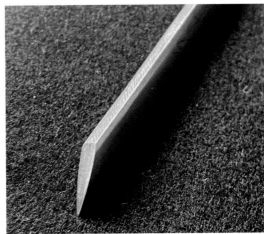

Spitsticker. This tool has a boat-shaped cross section, with curved sides.

'drawing' tool due to its facility to make curved lines. If it is kept sharp a medium tool will give you as fine a line as you will ever need, as well as the capacity to make the line swell. Over time you will probably acquire numerous spitstickers, as they all have slightly different characteristics. I should add that Bewick's pupil John Jackson in his *Treatise on Wood Engraving* makes no mention at all of a spitsticker. Having studied Thomas Bewick's toolbox, I can confirm that he owned several examples.

Graver

This tool has two forms – the square and lozenge type – and these shapes are clear from the profiles. The square graver produces a line with a pronounced swell and taper, whereas the lozenge version is more graduated. Some people never use a graver, feeling that the spitsticker can do the job of making a line that swells or tapers well enough. I would not argue strongly against that, but the exquisite line quality possible from a graver is worth considering. Gravers do not manage curves very well.

Tint Tool

This tool is designed to produce straight lines of even width and is so called because the trade engravers of the nineteenth century used the tint tool to produce areas of even or graduated tints. Today we would refer to a tint as a tone. As such, the results can look both mechanical

Tint tool. This tool has straight sides with a rounded tip, even though the smaller sizes appear to be pointed.

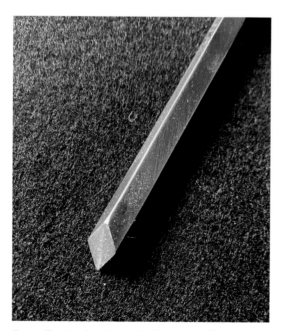

Graver. Showing the diamond and lozenge profiles.

or spectacularly skilled. The tint tool is essential for linear work where a line of even width is required, both straight and curved, as well as for stippling. In time you will want a wide range of sizes of this excellent tool.

Scorpers

These tools come in both round and square-ended versions and in a wide range of sizes. For clearing areas of wood, a scorper is essential. In time it is good to have a number of scorpers in different sizes suited to the clearing of a particular area. In their smaller and medium sizes both types of scorpers have mark-making capabilities, but in their larger sizes are primarily used for clearing. Note that the smaller round-end scorpers are functionally the same as larger tint tools.

Bullsticker

This is a more bulbous type of spitsticker with an oval profile and is a tool with lots of character. It has the potential to make lines swell and taper dramatically and, handled skilfully, can produce flowing, calligraphic flourishes. A secondary tool, but one whose use I value in my repertoire.

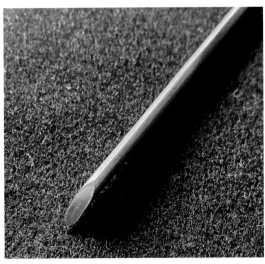

Bullsticker. The oval profile distinguishes it from the spitsticker; it may be regarded as a chunkier version of the latter.

Chisel Tool

A small chisel used for chamfering edges and corners, particularly useful when making 'floating' or vignette-type engravings. A large square scorper can do the same job, but it is worth having a chisel tool at some point. Both the chisel and large square scorper are useful for clearing ridges left when clearing areas with a round scorper.

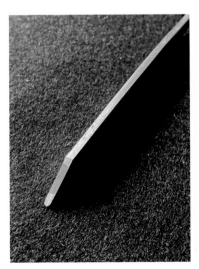

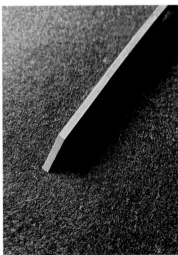

Scorpers. You will find it useful to have both the round- and square-ended versions in a variety of sizes.

Chisel. A small-scale chisel.

Multiple Tool

Engraving handbooks from across the decades all seem agreed on one thing – be wary of the multiple tool. This tool, due to the grooved underside can engrave upwards of two parallel lines. The number, width and spacing of the lines is a complicated affair and the best way to buy one of these tools is to try it out first. Caution is advised, because the effect is very often slick or mechanical. It gives the illusion that impressive marks can be had with ease. Multiple liner tools were used in the days when engraving was sometimes required to illustrate, for example, items of machinery with hard-edged precision. In addition, it was usually used in a ruling machine for absolute precision. However, there are creative ways of using these tools (*see* page 53).

EQUIPMENT

There is a variety of essential equipment in which all wood engravers should invest, in addition to tools.

Types of equipment

The following items will serve you well.

Sandbag

The leather sandbag used by wood engravers is a standard piece of equipment and worth the initial investment. It will probably outlast you, and your offspring will be delighted to find they have inherited a worn and battered leather bag full of sand, hopefully along with your house and savings. The wood engraver's sandbag differs from the one used by jewellers and be sure you buy the correct one. The engraver needs a firm, smooth and domed surface on which to pivot the wood block, whereas a jeweller needs the piece of work to sit securely on a soft, suede sandbag. Ian Corrigan, maker of Deerness Tools, makes very solid and high quality sandbags.

If you watch an engraver at work, you will see the block rotating constantly to facilitate smooth flowing lines as well as changing the

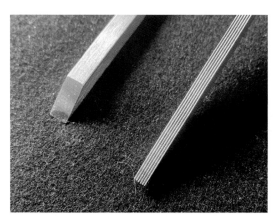

Multiple tool. This tool is available in a mind-boggling combination of lines per width.

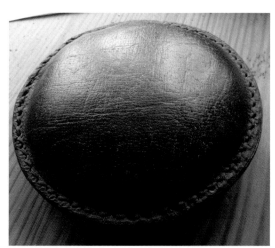

Sandbag. An essential piece of equipment for allowing mobility of the block, which will shape itself to your way of working over the years.

orientation of the block as needed. A six-inch diameter is the most useful.

Magnifying Glass

Wood engraving is a test for your eyesight, as I am frequently told at the end of a workshop. It is not uncommon for students (of a certain age) to conclude that they need new glasses, to the extent that I should probably look for sponsorship from an optician. Many engravers work with the aid of a magnifying glass on a flexible stand. There are lots of options out there, including models with built-in lighting. Whether you renew your glasses for ones that work extra well close up, or buy a magnifying glass, it is certain that if you cannot clearly see what you are engraving the results will be less than perfect.

Sharpening Devices

Traditionally wood engravers have used fine Arkansas stones to keep their tools sharp. These are very smooth, natural stones from the quarries of Arkansas, prized for their fine sharpening and polishing qualities.

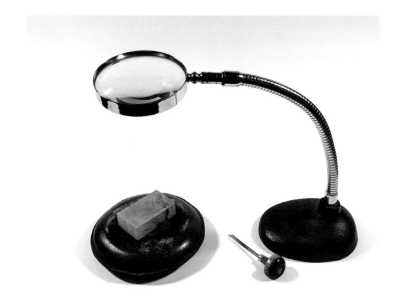

Magnifying glass. A glass on a flexible stand.

Sharpening devices. A modern ceramic stone from Spyderco and a traditional Arkansas stone.

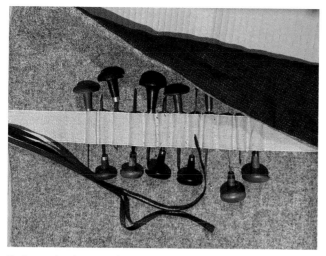

Tool wrap. An elegant tool wrap made by Sallie Temple.

Unfortunately, these quarries are now depleted of all the fine-grade stones and those being sold now are relatively coarse and unsuitable for producing a fine edge. However, the good news is that there are modern alternatives such as ceramic stones and diamond plates. Ceramic stones are virtually impervious to wear and can be cleaned with detergent and a pan scrub, restoring them to pristine condition. Diamond 'stones' consist of fine diamond particles bonded to a metal base plate. Both are excellent sharpening surfaces, but I prefer ceramic because the particles

eventually wear off the diamond plates creating bald patches.

Tool Wrap

The most common way to store tools has always been to use a felt (baize) tool roll. This protects the tips of the tools and is much better than keeping them loose in a box where the tips can knock against each other. The traditional green baize roll gave way to synthetic, fluffy felt that is prone to catching the points of tools as you insert them into the slots. I designed and had made a two-layer tool wrap in linen and fine woven wool, which allows easy insertion of the tools and a high level of protection when transporting your tools.

Printing Burnisher

If you do not have a printing press, or access to one, a simple tool known as a burnisher is a very good and cheap alternative. The burnisher is a more ergonomic device than the traditional wooden spoon. A printmaking burnisher is designed to fit comfortably in the hand and has a flat burnishing area with rounded-off edges enabling you to produce the required pressure over a greater area than a convex spoon face.

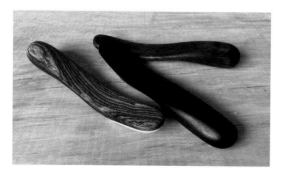

Printmaking burnisher. A simple, but effective tool. The shape has been fine-tuned, making it very comfortable to use.

I make burnishers in a variety of hardwoods, usually with a horn burnishing tip.

Printmaking Roller
Rollers range from inexpensive 'school'-type rollers with plastic handles and hard rubber inserts. The rollers are rarely perfectly flat and are too hard to transfer an even layer of ink

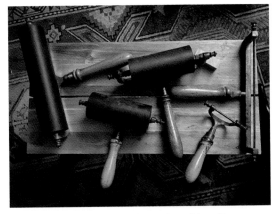

Printmaking roller. Various rollers with traditional heavy brass frames. The roller inserts are either made of nitrile rubber or a pliant plastic sometimes known as Durathene.

Black nitrile rubber and green Durathene rollers.

onto the engraving block. A step up from these is the student roller, which usually has a basic steel frame and wooden handle, but will have either a high quality synthetic or nitrile rubber insert. The best rollers traditionally have brass or bronze frames designed to last a lifetime or longer, with synthetic or nitrile roller inserts available in different shore hardness. They are expensive, but an investment. A good roller frame will allow you to leave the roller on its back, and this is important to prevent a flattening of the roller insert.

Presses
By far the best press for wood engraving is the type known as the platen press. The most

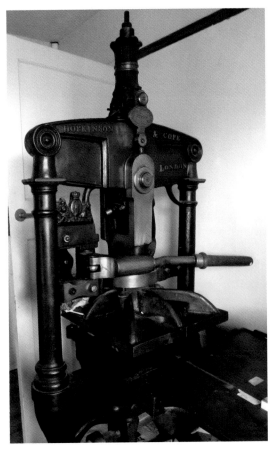

Presses. A Hopkinson and Cope Albion press, dated 1899. This item works as well today as it did in the nineteenth century. In the same room I have an inkjet printer that stopped working in 2012.

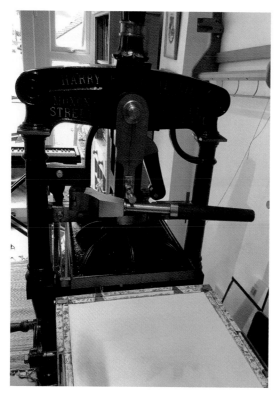

Modern Albion press made by Harry Rochat, owned by Sally Hands.

for a modest sum. Harry Rochat of London recently started remaking the Albion Press based on historic models but with improved engineering and fine tolerances. This press is a thing of beauty.

I am aware of several modern presses that are marketed for relief printing, but my experiences with them have not been positive due, in part, to the wooden elements in their construction. It was for good reason that the printers of the past moved on from using the inherently weak wooden presses of the time.

Other Presses

If you want to buy a press and cannot afford, or find, an Albion or Columbian, then I advise considering a book press. The smaller kind of 'copying press' is not so hard to find on eBay and in antique shops and is quite affordable. Even if you find a rusted model the restoration job would not be difficult as long as the surfaces of the base and plate are not badly damaged. Larger book binders' presses are worth considering, though they are likely to be more expensive than a copying press.

common are the Albion and the Columbian. Both were invented in the early 1800s and were a huge improvement on the wooden presses. They were a development of the historic Gutenburg press, which was originally a modified wine press. Once cast iron became a common manufacturing material, iron printing presses rapidly replaced the creaky wooden presses. Following the rapid and drastic changes in commercial printing in the mid-twentieth century, proofing presses such as the Albion were discarded and often scrapped. Wood engravers, universities and print studios grabbed them when they saw them, often for little or no money. Now they are highly desirable with a hefty price tag. Nevertheless, they sometimes emerge from the shadows of some old print shop or school

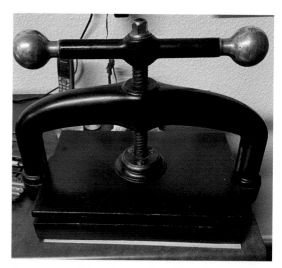

Copying press. Although not as desirable as an Albion press, these small cast iron presses can be made to work well for the printing of small engravings.

Ink

Traditional oil-based letterpress inks are most commonly used, as these are stiff in consistency and designed to stay on the surface and not creep into the engraved lines. Avoid water-based inks because they are too fluid. Water washable, oil-based inks are popular, but I would always opt for traditional inks. The water washable factor is not significantly easier in the clean-up process. Cranfield make a fine

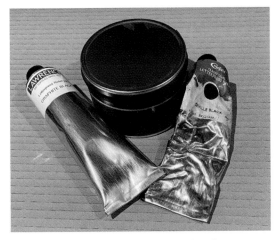

A selection of inks. Tubes are more convenient for use now and again. Pots are economical if used regularly, but can form a skin on the surface.

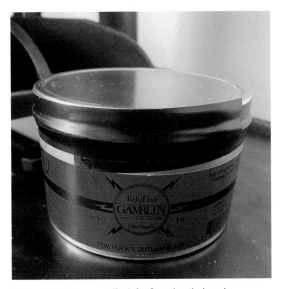

Outlaw Black. A very stiff ink for fine, detailed work.

range of oil-based blacks, having different undertones, some warm, some cool, and so on. For most purposes this is the range I would recommend. Please note that Cranfield also make these inks for T. N. Lawrence, sold as their Oil-Based Letterpress range. The blacks are subtly different from each other, and this becomes apparent when rolled out thinly on the slab, revealing the undertone:

Carbon Black This is a neutral black with no undertone.
Graphite Black A silvery black due to the graphite pigment. Gives soft grey blacks, suitable where subtle greys are sought.
Midnight Black Blue black, like carbon black but with blue undertones.
Plum Black This one has purple undertones, very clear when rolled out thinly.
Seville Black A warm black with orange undertones – hence the name.

Another excellent ink and one I would highly recommend is Gerstaecker Stiff Carbon Black, available from Great Art. If your engravings contain exceptionally fine mark-making, then you will find a stiffer ink will give better results. The best I have found is made by Gamblin and goes by the name of Tom Huck's Outlaw Black. This is much stiffer than any other commercially available ink today and takes some persuading to roll out on the slab. It is well worth the extra work, but not a beginner's ink. It is only available in tins and care must be taken to maintain an airtight seal to prevent the ink skinning over. I advise pouring a layer of water on the surface before replacing the lid. Tubes are less wasteful in this regard, but care must be taken to avoid the cap and screw thread caking up with ink. Printing is a messy business and rubber gloves are advised.

Solvent/Cleaners

Until quite recently the standard cleaning substance in a print studio was white spirit, which is a very efficient solvent for cleaning up

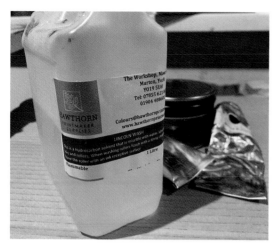

Solvent/cleaners. Lincoln Wash, my solvent of choice. Far less toxic than white spirit and just as effective.

and less receptive to the inked block. Internally sized or waterleaf (minimally sized) papers are soft and accommodate the surface printing in relief and letterpress work. The range of Japanese papers is extensive and something of a minefield. I advise buying samples and sample packs from the Awagami range to see what suits your tastes. Papers for press work are easier to navigate and John Purcell Papers of London provides samples and a knowledgeable service. My own favourites are Arches BFK Rives, Arches Velin Cuve, Somerset, printmaking grades in the various shades of white. At the time of writing one of the most popular papers for engraving, Zerkall, is no longer available, but John Purcell Paper has had a replacement made, called *Liber Charta*, available in two shades and three weights.

oil-based inks. It is, however, harmful to the skin (and beneath) and the environment. For all that, a small amount is very effective, and you may not want to rule it out, if you wear rubber gloves and dispose of the oily rags carefully. There are numerous other ways to clean rollers, inking surfaces and blocks and these vary from barely to very effective. Some are citrus based, and these are mostly used in the print studios, along with vegetable oil and even baby wipes. The issue I have with all of these is that they are slow to break down oil-based ink and usually require copious quantities and a mountain of rags. My favoured cleaner is Lincoln Wash from Hawthorn Printmaker Supplies It is a hydrocarbon solvent which is almost as effective as white spirit, without the odour or toxicity.

Papers

For relief work it is best to use a soft-sized paper. Glue sizing is what holds the pulp together in the paper-making process. On a spectrum, letterpress papers are nearer the blotting paper end, with hard-sized watercolour papers at the other end. The latter are the least suitable for printing wood engravings since the surface is hard-sized, making these papers unyielding,

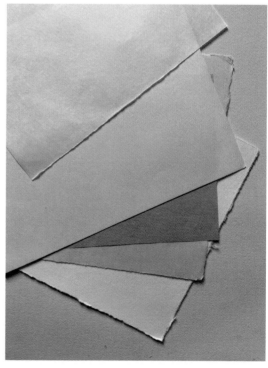

A selection of Japanese and European papers in different shades ranging from bright white to khaki. Deckles (feathered edges) are usually artificial, except on handmade papers. They serve no purpose unless you frame the engraving without a mount to show the deckles.

Other materials

For tracing down the image onto the block you will need thin, layout-type paper or tracing paper, old-fashioned carbon paper and a hard pencil (2H or above) and either Indian ink, fountain pen ink or gouache for toning the block.

Endgrain Engraving Blocks

Since no one is exactly certain who invented engraving on endgrain wood, or when it happened, I like to speculate that it was

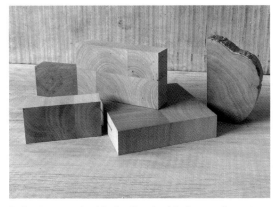

Endgrain engraving blocks. Showing blocks stored on edge. Storing endgrain blocks on edge allows air to circulate around them. They should be kept away from sources of heat and direct sunlight.

The author planing the smooth surface on a block.

a eureka moment. The long journey from carving on sidegrain wood, with the increasing aim of making finer and finer cuts to compete with copperplate work finally reached its goal one day when a woodcut artist decided to play around with engravers' tools on a piece of polished endgrain boxwood. At last, the woodcut process could match the refinement of a copperplate image. Since the endgrain form of wood has no directional grain and presents microscopically as a tight cluster of tube ends, the polished surface does not interfere with the engraving process. Blockmaking is a specialised skill and most engravers will have better things to do than attempt to make their own blocks.

Boxwood

Surprisingly few woods have proven themselves suitable for engraving, the best being boxwood (*Buxus sempervirens*), that slow-growing shrub, which eventually becomes a tree, if left for 100 years and more. Papillon praised it in the eighteenth century in his labours to find ever-finer ways to make a woodcut. He did not quite manage the transition to endgrain, but still found box the best of all woods for the job. Thomas Bewick used it extensively, though he sometimes worked on pear. A good boxwood block is a beautiful object, honey coloured, polished and allowing for the finest and most crisp cutting. Although not a requirement today, it can withstand many thousand impressions with no deterioration. Due to the slow growth rate, trees of a suitable girth are becoming increasingly scarce. It seems likely that most of the ancient box trees were felled in the nineteenth century for the extensive engraving trade. Nevertheless, boxwood blocks are still being made. As someone who engraves and makes engraving blocks, I strongly advise beginners not to go to the expense of buying boxwood blocks. Most engravers find that lemonwood, in particular, is more than up to the job.

Boxwood.

Lemonwood.

Pearwood.

Maple.

Holly.

Lemonwood

Sometimes known as Castello boxwood, this is not a true boxwood genus. However, it is a very good and less costly alternative to boxwood. Usually found in South America (but also New Zealand), it is called lemonwood because the leaves smell faintly citrus. It is a pale straw colour and rather bland in terms of grain. This, however, makes it suitable for wood engraving purposes. It grows to much larger dimensions than boxwood, which helps in the making of bigger blocks without too much piecing together of sections. Today most engravers use lemonwood.

Pearwood

Before the introduction of lemonwood as an engraving wood, pearwood was often used as a second-tier wood. It is softer than both box and lemonwood, but cuts pleasingly and is easier to clear large areas. The feedback through the tool is not as crisp as with the other woods, but the cutting is nevertheless clean and precise

(providing your tools are sharp). Pear is also a good choice for larger work when cost is an issue. Often steam dried, it is a pale pink colour. I often used pearwood for commercial projects because it was faster to work with.

Maple

American hard maple has been used for a long time by engravers in North America, which is not surprising due to it being available in such abundance. Maple is a pale beige colour and is usually very consistent. It has a slightly coarse feel under the tool compared with the other woods, but is still capable of precise and clean lines.

Holly

Holly is a very nice wood for engraving, with the advantage of it being creamy white. This means that your cutting shows up in strong contrast under the darkened surface. Usually butter smooth in consistency, it is still able to hold fine linear work. However, it is problematic for the block maker because it is difficult to obtain holly as seasoned wood. It splits and bends badly during the seasoning process and for this reason is not a commercially available timber, despite its weed-like abundance in nature. It is highly recommended.

Once you have a workable set and tools and other essentials, as described, your main expenditure will be on blocks. These should be regarded in the same way as a painter might value a fine quality linen canvas and something on which you will spend many hours of creative labour.

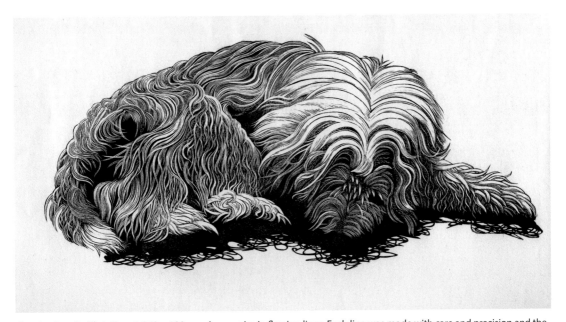

Sleeping Beardie, Chris Daunt, 260 × 120mm. An exercise in flowing lines. Each line was made with care and precision and the engraving took me several weeks!

BASIC PROCEDURES

Before beginning an engraving there are preliminary tasks to be carried out to ensure that your engraving is the best it can be and, as far as possible, free of avoidable mistakes.

THE DRAWING

Once a mark is engraved into the block, it cannot be undone. With this in mind I suggest that the practice of making a carefully thought-out preliminary drawing is a wise idea. Unlike

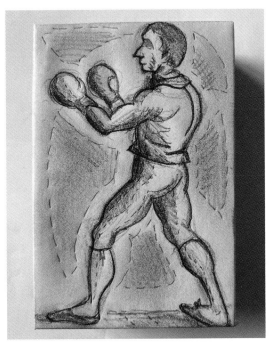

A working drawing with shading and tonal areas indicated with dotted lines.

Mapping out the space in which you will plan your engraving.

the oil painter who can scrape off or rub back a mistake on the canvas, the wood engraver must live with a mark made in error. The best way to minimise errors is to make and correct them at the drawing stage.

Toning the block with diluted Indian ink.

Take your block, place it face down on a piece of paper and draw around it. Here you have the space into which you can map out your drawing. Do several of these and use them to arrive at the composition you like best before shading in the tonal values. At this stage do not bother to anticipate the marks you might make with the engraving tools – your only task here is to establish both composition and tonal values. First, decide which areas will be black (untouched wood) and which will be white (cleared away). Then work between these two polarities with shades of grey. If you feel inclined, you can even number the tones from one to six (could be more or less) with white being number one, and black six. This leaves you with four greys in between. I will often delineate between these tonal zones with a dotted line. This dotted border does not mean that there will be a clear-cut tonal jump in the engraving, but rather indicates where the tone shifts up to the next zone. Regardless your method of engraving, this transition will be more or less smooth from one tone to another.

Do not be concerned if your well-worked drawing begins to look like a painting by numbers diagram. Remember, this is a working drawing and can be peppered with corrections, numbers and notes. Imagine that you are only the artist and not the engraver and you will be handing over this drawing to the engraver (as would have happened in the nineteenth century, when engraving was carried out by tradesmen). The engraver would require as much information as possible to interpret your drawing as a beautiful and accurate engraving.

TRANSFERRING THE DRAWING

Toning the block

Most wood engravers will tone the block in some way so that they can clearly see the lines they are engraving. A few do not, but I have yet to hear a convincing reason not to darken the surface.

If the tone is too dark then you will not be able to see your tracing, too light and your engraving will not be in sufficient contrast. I am aware that there are numerous ways of approaching this task, but the method I propose you start with is the most used and, in my view, the most intuitive.

Indian ink is good, but make sure you dilute it with water to a ratio of roughly 20 per cent water to achieve a nice grey. Experiment to find out what suits you best. Fountain pen ink is

A block toned with blue/gouache. The matt surface will take additional pencil work well, but is not water resistant.

also suitable and if you use black this will need less dilution due to it being less concentrated than Indian ink. Some engravers like to use a coloured ink.

Apply the ink by depositing some on a piece of folded cotton, or kitchen towel, and rapidly wipe it across the block. Alternatively, brush on the ink, but avoid using too much ink on the block, as this will open up the fibres of your mirror-polished block if you flood it. Once dry (five minutes or so), buff the surface with kitchen paper and the polish will return.

Hilary Paynter always tones her blocks with a thin layer of grey gouache and this gives a satisfying matt and even surface, which is very pleasant to work with. Again, do not overload the brush. Apply the gouache swiftly, as leaving brushstrokes will affect the inking of the block at the printing stage. You can use any colour and tone you wish. The case for using some shade of grey, either warm or cool, is that it is easy on the eye while engraving and gives you a reasonably good idea of how the printed block will look.

An alternative to using water-based ink is to roll out some printing ink thinly onto the block and then rub it around with a cloth to even out the covering. This has the advantage of allowing you to move the ink around until you get an even tone without streaks. However, it will take overnight or longer to dry thoroughly. If you have the patience to wait, this is a good method. One disadvantage is that an oil-based surface tends not to hold the carbon tracing as securely as the other grounds. As with most of the procedures I describe, try them out to see which works best for you.

Carbon paper transfer

This is the most commonly used method to transfer a drawing onto the block. Get some old-fashioned carbon paper on eBay. Vintage carbon paper is cheap and easy to get, as very few people these days have any use for it. It is still made but varies in quality, the worst leaves a line that rubs off easily. There is also a non-waxy transfer paper

available in various colours, but this leaves a line that rubs off quickly and needs to be sprayed with fixative. My advice is to avoid it.

Drawing on the block

A confident artist might like to draw directly on the block (from their working drawing) either before or after toning the block. A pencil line will be barely visible on or under the toned surface. The engraver Joan Hassall would draw onto the untoned block with a pencil, then go over the drawing with a dip pen and Indian ink. Once dry, this drawing can be washed over with a slightly diluted coating of the same Indian ink, allowing the drawing to show through. Be aware that Indian ink from a nib can leave a thick line, which may need to be removed before printing. Fine liner pens may be a better option.

An unusual variation on the above was that used by Richard Shirley Smith, who toned his

An Indian ink brush drawing on the block, overlaid with dilute ink, gives good visibility.

blocks with a layer of white gouache or Chinese white. He then made a detailed and fully shaded drawing on this whitened surface and produced some of the finest engravings of the twentieth century. Such an approach seems to me the most unlikely way of engraving if you are to gain any sense of how the finished print might look as work.

Photocopy transfers

Finally, a modern method, one of the few things that would surprise Thomas Bewick were he to visit the world of twenty-first-century engraving. It is possible to skip the tedious business of tracing down your drawing with the help of a computer, an inkjet printer and some sheets of waxed printer paper. Scan or download the drawing onto your computer making sure it will print out actual size. If you use photoediting software, increase the contrast so that the printed lines are as dark as possible. Load the waxed paper into the printer and print. Take care not to touch or smudge the printed sheet as the waxed paper will not allow the ink to dry and will easily release it onto the block.

Position the block face down onto the printout, taking great care that it goes down accurately – you will not get a second chance if you misalign. Either press down firmly or run

it through a press if you have one. Lift off the block and a perfectly clear, offset (reversed) image will be permanently fixed onto the block.

The image will be dark grey rather than black, so the tone you apply to the block needs to be slightly lighter than that used for the other methods of transfer. Note that this will only work using an inkjet and not a laser printer. Pete Lawrence uses tracing paper for this method and scribbles or burnishes over the image. He confirms that this works well to transfer the image onto the block.

Tracing onto the block

First of all, cut the carbon paper to fit the block, with flaps that can be folded and taped

Carbon paper fixed onto block.

Carefully pressing the block onto the wax paper transfer. A steady hand is essential!

Pull the carbon paper taught and tape down the edges having first mitred the corners. Doing the same with the drawing will ensure a crisp tracing.

Using a hard, sharp pencil held upright will trace an accurate line through the two layers.

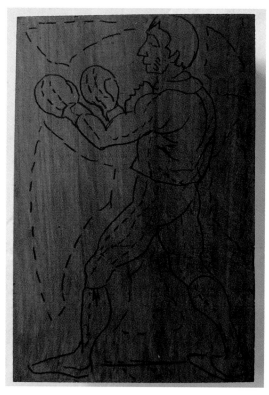

Carbon tracing. A medium-grey tone shows the tracing clearly and gives a dark tone to reveal the wood as you engrave.

Protecting the drawn and engraved areas of the block with a paper window.

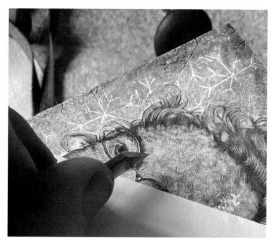

If you are concerned that your tracing will rub off as you work, protect it with a paper shield.

onto the block. Mitre the corners to make the folding neater. Stick down with tape at each edge (not too much, you have to remove it). Do the same with the drawing. Pull both the

carbon paper and the drawing taut as you tape them to the block, as this will result in a sharper tracing.

In order to get a fine line from your tracing, use a thin paper for your tonal drawing. The thicker the paper, the more difficult it is to get a fine, accurate tracing. Layout paper works well. You can also use tracing paper, which allows you to flip the drawing over and trace in reverse if it is important that the orientation of the print matches your original drawing. Lettering would be an instance where this matters.

For the tracing I use a sharp, hard pencil, something in the region of 4H. A biro or stylus can also be used, but take care not to press so hard that you indent the wood. Moderate pressure is best, but you will only know what is moderate by trial and error.

Tracing down is tedious and I do not know any engraver that enjoys it, but you will be delighted to see a crisp black carbon line on the grey surface as you remove the papers. It is a good idea to lift a corner of the drawing and carbon paper to make sure you have traced everything before removing it completely. Once the drawing is on the block you will find the line is clear on the toned surface, as well as resistant to being rubbed off as you work. However, to prevent any loss of drawing from the rubbing of the hand across the block, some people put a piece of paper on the block to protect the drawing. I know someone who cuts a window in a piece of paper about the size of the area she is working on so that surface is completely protected. This is a good idea if you do not mind seeing only the section you are engraving.

Arranging the table

Once you have traced down the drawing, you may want to organise your worktable. Placing the sandbag on a rubber mat prevents it rotating on the table – you want the block to rotate, not the sandbag. Have your drawings and any other reference material in front of you as you work. These will have all the information

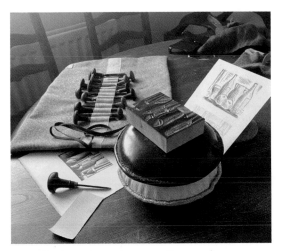

Start off with good intentions, even if your workspace quickly descends into chaos.

you need, even if you decide to discard some of it. Your tools should be laid out with easy access and, ideally, in some kind of order. Black and white pencils that draw on wood are good to have at hand should you want to shade on the block. Do not forget small pieces of card to prevent bruising (indenting edges with the belly of the tool) the block. Once the engraving begins to take shape, some engravers sprinkle talcum powder on the block and clean off the surface. This is an effective way of assessing your progress before taking a proof.

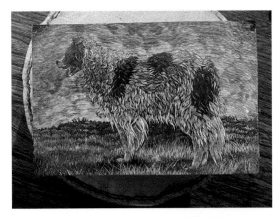

If your work is particularly fine, it can be difficult to assess progress. Rubbing talcum powder into the lines will make the image wonderfully clear without the need to take an early proof.

Holding the tool

The mushroom handle has a flat, which is there to give clearance across the block. A full round handle would impede movement, especially on a larger block. It also serves to stop the tool rolling off the table. With the handle set comfortably in your palm, flat facing the table, let your forefinger and thumb fall naturally either side of the steel. The traditional hold is to lead with the forefinger, but many engravers find it more comfortable to place the forefinger nearest the tip. Where the forefinger leads, the practice is for the tool to slide against it as you engrave. In this way, the tool is propelled forward from the hand – no pushing from the arm. If this is not comfortable, then a pen hold is acceptable. Avoid placing your finger on top of the tool if you adopt this hold, since it places downward pressure on the tool and obscures your view of the line you are cutting. I advise that you try using the traditional hold, but not to get troubled if you cannot manage at first. I spent several years as a Cistercian monk and recall one of the old monks saying to me 'pray as you can, not as you cannot'. So, hold the tool as you can, not as you cannot. Wood engraving tools are held the same whether you are right- or left-handed, and the technique is the same.

Many students opt to hold the tool like this.

Posture

The trade engravers of the nineteenth century were aware of the importance of posture when engraving. They would often work on two or more sandbags, or have the sandbag perched on an angled plinth. Sometimes an engraver would stand to work using something like a lectern. When you consider that nineteenth-century workers usually worked a six-day week and much longer hours than we are used to, engravers

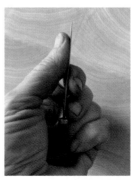

The tool handle should be angled for clearance across the block. This is the traditional hold, leading with the thumb. Notice the fingers are tucked away, the ring and little finger hooked into the hollow of the handle.

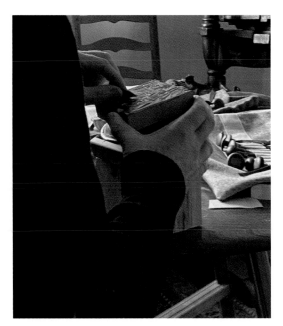

Correct posture.

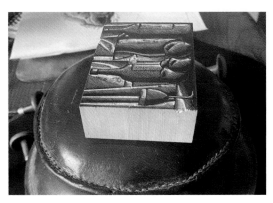

Two sandbags stacked for extra height.

Sandbag on a rough and ready plinth; this will help prevent neck strain.

would have developed strategies to protect their backs and necks. I usually stand to engrave and no longer get back pain.

FIRST CUTS

For a beginner this is a big question. In my classes I look around the group and know right away who has just completed the tracing stage: they are the ones with a frozen look on their face. It can be intimidating to know that your first cuts cannot be undone. In fact, this feeling of apprehension remains after ten, twenty or more years of engraving and it is a good thing. Wood engraving is nothing if not considered and premeditated (well, for most engravers – there are exceptions).

Musicians are trained in the rudiments of music through scales and so on, and in order to find their way around their instrument they spend countless hours in practice. This same disciplined approach can be applied to wood engraving, so I invite you to begin learning the craft element by working through the sampler blocks in the next chapter.

TOOL SHARPENING

It is important that you learn how to maintain a sharp edge on your tools. The standard sharpening stone for wood engraving was a fine Arkansas polishing stone. These are marble-like stones varying in colour from dark grey to white that yield a fine polished face on the tool. However, the Arkansas quarries are now depleted of all the finer-grade stone and those that are now being sold are much too coarse for our purpose. You can, however, find them secondhand. There are modern alternatives, the best being ceramic stones. Spyderco, the American knife manufacturer, makes very good ceramic pocket stones in both medium and fine grit. If your budget allows, get both, but either will give you very good results. Ceramic stones

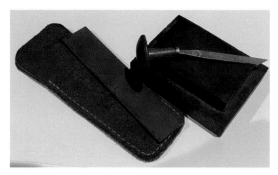

Left: ceramic stone and leather pouch (Spyderco). Right: traditional Arkansas polishing stone.

Tool sharpening. This is much simpler than beginners imagine. If the fingers are placed close to the tip and care is taken not to rock the tool, your technique will be good. Long nails will have to be clipped.

are impervious to wear and can be used with or without lubricant (oil or water).

Although you would expect that a tool comes sharp and ready to use from the manufacturer, this is not always the case. Deerness tools always come ready sharpened and at an angle suited for wood engraving, that is something in the region of 30 degrees (gravers for copperplate work have a steeper angle to make the tip stronger). I would make a distinction between sharpening and honing an edge, and all that you will usually be doing is honing a tool that is already sharp. Honing may be described best as polishing an edge, whereas sharpening is a process that removes steel when the edge is lost. If your tool is damaged or beyond honing, then it's best to send it for re-grinding to one of the services listed in the Suppliers section of this book. I'd strongly advise caution in this matter, using only someone who is experienced in working with engraving tools.

Honing on a medium or fine grit stone of your choice is easy once you understand the importance of keeping the tool flat against the surface of the stone for the duration of the honing process. This is best achieved by gripping the tool with your thumb and forefinger close to the tip and slightly touching the stone.

In this way the tool will be less inclined to rock. You then rub the tool across the surface with moderate pressure in one of three ways: up and down, side to side or in small circles. I favour the latter, but all that matters is that the tool is kept flat on the stone for the entire time. In the course of your engraving, you will get a feel for when the tool needs honing and ten to fifteen strokes on the sharpening stone is usually enough.

Now that you have some tools and equipment and the basic procedures have been discussed, it is time to begin your engraving practice on sampler blocks.

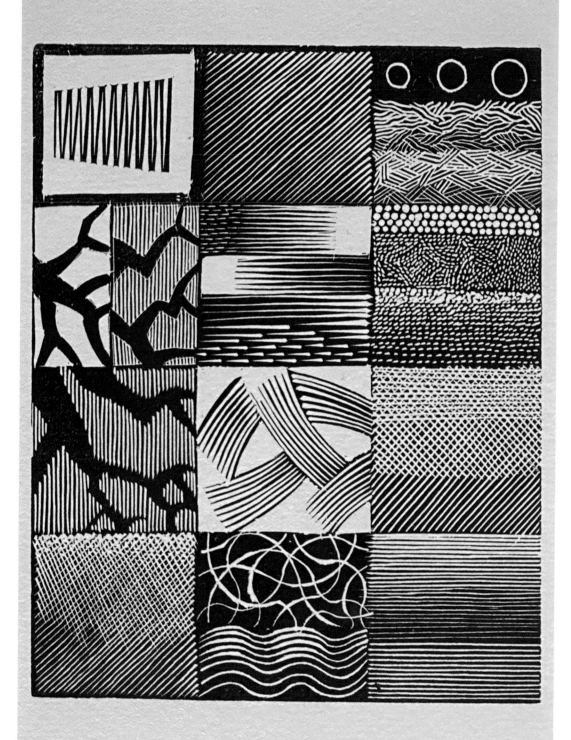

SAMPLERS

BASIC SAMPLER

Before embarking on your engraving, it is wise to do a small sampler, which will help you learn how to hold the tool and explore a range of the marks available to you. Use a block approximately 90 × 30mm, preferably lemonwood. Darken it using one of the methods described above and divide into six sections with a pencil or marker.

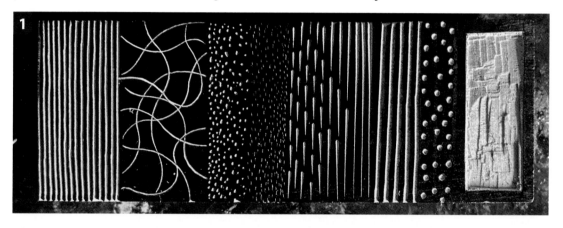

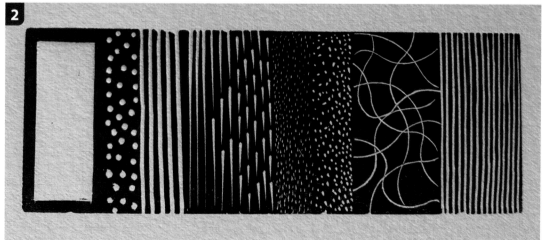

Basic sampler. The block and the print.

Section One: Parallel Lines

The first tool to use is the tint tool. The lines you are to make are straight and without any variation in thickness. Although you will not be rotating the block for this section, it is good practice to use the sandbag to support the block. When holding the block, remember to keep your fingers below the surface in case the tool overshoots. Hold the tool at a low angle and start the cut just in from the edge.

Engraving tools have a narrow range of operation – or 'sweet spot' – and you will quickly learn what it is. If too low, the tool will skip across the wood, too high and it will embed in the wood and require you to rock the tool from side to side as you engrave. The cutting should require very little pressure. As far as possible keep the lines straight and evenly spaced. Draw some guidelines on the block – without them you are sure to go off track.

Section Two: Curved Lines

Here you will learn how to make curved lines by rotating the block on the sandbag. Use a spitsticker and keep it at the same low angle you used in the first exercise. Press the tool forward and rotate the block to make the curved lines. Remember that it is the swivelling block that produces the curve and not the action of the hand pushing the tool. This is the only way to make fluid lines in wood engraving and a fundamental skill to master.

Section Three: Stippling

In the third section you will use both the tint tool and the spitsticker to stipple. Start with the tint tool and raise it to an angle of roughly 25–30 degrees. Press it into the wood and flick out the wood using your forefinger as a pivot. This action will leave a dot. The closer the dots, the lighter the tone. Do the same with the spitsticker and you will see that instead of a dot this tool jabs into the wood. In both cases it is very important that the wood releases, leaving the surface smooth. Burrs created by poor stippling technique cause problems in printing, as they hold ink leaving an unsightly blur around the dot. The surface of the wood will feel like a rasp if your stippling technique is poor.

Section One. Straight lines of even width using the tint tool. This is the best tool to begin with.

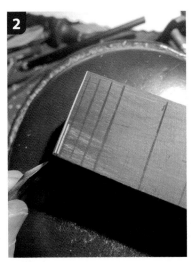

You cannot engrave from off the edge, so start a little way in.

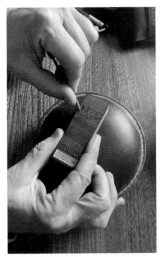

Section Two. The block is held like this with your other hand and rotates as you push the tool forward to engrave smooth, flowing lines.

Section Four: Graduated Lines

The next mark is one of the most useful to have at your disposal. Use a square or lozenge graver and hold it very low on the block, just high enough for it to bite into the wood. Engrave forward and gradually raise the angle as you proceed, until the tool comes to a halt, then flick out the wood. At first, keep the lines short until you are comfortable with this maneouvre, then lengthen them. For this to succeed you must begin the line as fine as possible. The ability to make a line swell like this is invaluable for tonal transitions and can also be made with a spitsticker.

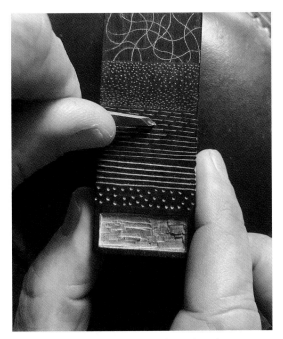

Section Three. Stippling can be done with either a pointed tool or a tint tool. The picture shows a graver.

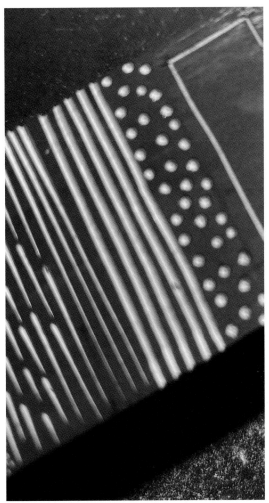

Section Four. Lines that swell, from fine to broad.

Section Five. Broad lines and stippling with a medium round scorper.

Section Five: Broad Lines

Use a medium round scorper and repeat what you did with the tint tool in Section One. You will encounter greater resistance from the wood as you engrave with this relatively large tool. Make the lines incrementally and the likelihood of slipping will be greatly reduced – remember to keep your finger below the surface of the block because you are using greater force with this tool.

In the second half of this section use the scorper to make dots. Here the technique differs from stippling in that the tool is set into the wood and the block rotated full circle to give a large, symmetrical dot.

Section Six: Clearing

In wood engraving, you must work for your whites; in drawing, they come free with the paper. Draw a rectangle, leaving a frame, then cut a line around the inside with a tint tool. This has defined the area to be cleared with a medium round or square scorper. As far as possible, engrave from an edge towards the centre so that any overshooting is less likely to cause damage. However, you must avoid

damaging the edge with the belly of the tool. This bruising or denting of an edge is easily prevented by placing a thin piece of card under the tool as it levers against the wood. If you indent the wood, this will show in the finished print. It is usually the case that beginners do not clear deeply enough and that they leave ridges which foul the cleared areas. Go far deeper than you think you need to. Spend as much time as you need on this first sampler block and repeat it if you feel the need.

INTERMEDIATE SAMPLER

Here is a second, small sampler block, but slightly more advanced. The skills learned in the first can be applied to this one. Here you will notice that the tint tool lines are making a graduated tone, as does the stippled area. There is also a set of curves that swell and taper and for these you can use a spitsticker or – if you have one – a bullsticker. Finally, a black line swirl, which will involve cutting around a drawn line and clearing away the surrounding

Section Six. Good clearing technique is very important. Always protect the edge you are working from with card or stiff paper. The engraved channel allows you to safely engrave into an edge if you prefer not to work from the edge.

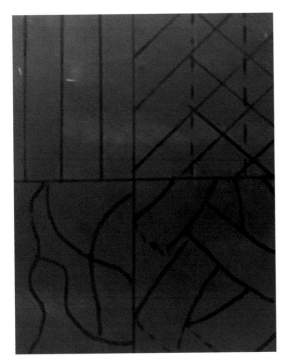

Section of the sampler block showing traced guidelines on the toned block.

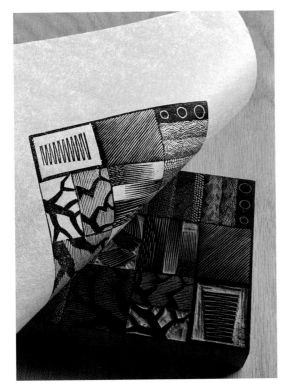

Print being pulled from the sampler block.

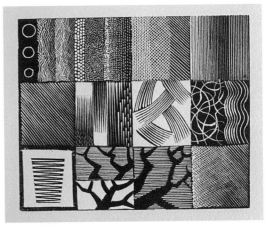

Completed print from the advanced sampler block.

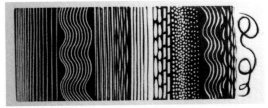

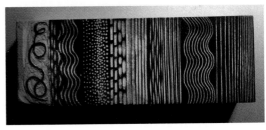

A slightly more advanced sampler to try after you have completed the first.

wood. I predict that it will take you as long to do this section as it took to do all the preceding sections. Such is black line engraving.

ADVANCED SAMPLER

Tonal shifts

In the first sampler block, the tint tool was used to make a set of close parallel lines running the width of the block with the aim of creating a uniform tone. In this instance, the aim is to engrave a graduated tone by gradually increasing the distance between the close-set

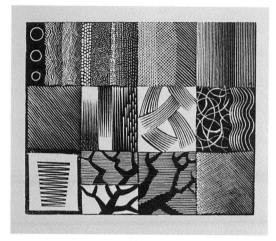

Print from advanced sampler block.

Cross hatching.

Tonal shifts.

lines and switching to a slightly finer tint tool. In this way you can modulate the tone from dark to light, the smoothness of which will depend on your mastery of the process. You can, of course, go from light to dark if you prefer. The first gradation is less pronounced and the second shows more range. Over time you can acquire a good range of tint tools, from fine to broad.

Crosshatching

Still using the tint tool, lay down an area of even, diagonal tone, known as hatching. Halfway across this, begin another layer of diagonal tone at about 90 degrees. You now have a second, lighter

tone, and this technique is called crosshatching. Although it may seem that there is an abrupt jump from the first to the second tone, the printed block will show a more gradual shift. This secondary tone can now be the basis for a third, lighter tone. Halfway across this area of crosshatching lay down a third zone running vertically. Engraving across a set of lines feels like riding a bike across a cattle grid – the ridges will try to throw you off.

Tonal Stippling

The tint tool is better suited to stippling than the other tools because it produces more of a dot than a jab. These dots can be graduated tonally in the same way as linear-mark-making: the closer together the dots, the lighter the tone, and vice versa. Using a linear pattern, make an area of even stippling as close as you can manage without the dots overlapping. After five or six rows adjust the distance between the dots (closer together) to lighten the tone. Repeat this sequence, each time increasing the gap between the dots until the tone is dark grey. You can also indicate a pattern, such as scalloped shapes, to create an area of stippling that has more interest than random dots.

Finally, take either a large tint tool (Lyons number 4, for example) or small round scorper

Tonal stippling.

(Lyons number 54) and make an area of stippling using the technique described in the first sampler block where the block is rotated 360 degrees. In the first block the dots were random and dispersed. Here the aim is to set them evenly placed and close together.

Basketweave

This is a way of creating both tone and texture with the tint tool. Starting with a fine tint tool, engrave small sets of three or four lines in one direction, then further sets at differing angles to make a basketweave pattern. As with the straight lines, a graduated tone can be had by moving up to a broader tool. A variation is to make the lines wavy.

Circles

The tint tool is also the best tool for engraving circles, especially tight ones. It was said of the great Italian master Giotto that he could draw a perfect circle, freehand. If you can do the same, or do not mind wonky circles, skip the preliminary drawing. If you are a mere mortal, and would like to aspire to the perfect circle, draw the circles using a template. Press the tip into the wood, then push and rotate

the block on the sandbag, slowly and in increments until you complete the circle. The process feels as though the resulting circle will be jerky, but you will be surprised at the smoothness achieved.

Patterned stippling.

Basketweave.

Circles.

Curved lines.

The reason the tint tool is best suited to engraving a circle is because the line it makes does not vary in width throughout the procedure. A spitsticker has a tendency to make a circle where the line varies in width as it cuts.

Curved Lines

For fluid curves with variation in line thickness and drawn quality, the spitsticker works well. In the basic sampler block you learned how to rotate the block to produce a fluid curve. A development of this line would be to vary its thickness by lifting and lowering the tool as it pushes through the wood. This is challenging, as it requires the brain to do three things at once: to push the tool forward with one hand whilst raising and lowering to produce a swell and taper. At the same time, you must constantly rotate the block on the sandbag to achieve a smooth curve. The resulting line has

a calligraphic 'copperplate' quality. First of all make these lines serpentine, then allow yourself some freedom to take the line for a walk, all the time using the sandbag for rotation.

If you have a bullsticker, you can produce lines with greater variation than with the spitsticker.

A nice variation is to draw sweeping lines on the block then take out the areas between using a tint tool and scorper. In the remaining areas of black, carefully engrave curved lines that gradually open out at the ends to feather off into the white zones. You can re-enter the lines at the edges to fine-tune the tapering.

Brushstrokes

The shapes were drawn onto the block and the spaces between cleared. I then used a spitsticker to line the strokes, making the lines swell at the edges to feather into the white.

Graduated Lines

Because the graver is slightly reluctant to make curved lines (though it can be coaxed, should it be the only tool you have on a desert island) we will work with what it does best: marks that

Brushstrokes.

Graduated lines.

but still biting in the wood and gradually lifting as it moves forward. This produces a smooth swell or opening up of the line. Do this again here to limber up. In this exercise the aim is to create a tonal shift from black to white by means of a set of these lines. First, clear an area of wood from the bottom quarter of the section. Begin engraving a quarter of a way from the top, and make a graduated tone by means of this set of lines moving from black to white. It is hard to exaggerate the importance of developing this skill as a highly effective way of modelling form. You can further modify the subtlety of the transition by breaking up the black zone with broken lines.

Shaded Hatching

Hatching with a graver can be more subtle than with a tint tool. This is because of the shaded line, an option not available with a tint tool. Use either a square or lozenge graver, whichever you feel most comfortable using. Generally, a lozenge graver is easier to use for a beginner,

Shaded hatching.

go from fine to broad in a graceful stroke. Here you can draw on the practice of that very subtle manoeuvre in the first sampler where the line begins with the tool almost flat on the surface,

as it is more likely to produce a smoother transitional line. In time you might prefer the broader range of a large, square graver. This is a challenging exercise, but essential to master with practice. There are three skills to develop here: laying down lines that are parallel (in this case diagonal), evenly spaced and moving from fine to broad. It is essential to draw a set of lines on the block with a ruler to avoid running off track. This will certainly happen if you do not have guides to follow. You are not drawing on every line, only at intervals. Each line is engraved with as much careful shading as you can manage and this is best achieved by working incrementally, rather than in one virtuoso sweep.

Shaded Crosshatching

Starting with the same base of diagonal hatching, overlay another at roughly 90 degrees halfway across the area. The tapered line lends a more subtle shift of tone than that produced by the tint tool. At the edge you could stipple over the hatching to further lighten the tone

as well as adding texture. Look at the work of Agnes Miller Parker for beautiful examples of this method.

Shapes

The shapes were drawn onto the block and the spaces between cleared. I then used a spitsticker to line the strokes, making

Shaded crosshatching.

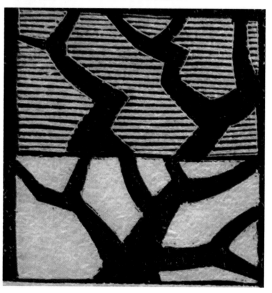

Shapes.

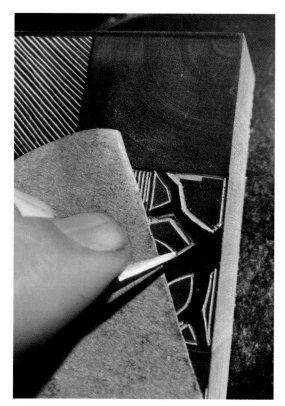
Protecting an edge with cardboard strip to prevent bruising.

the lines swell at the edges to feather into the white.

I have heard it said that wood engraving is all about edges, how edges butt up against each other. In general, it is best to avoid outlining objects against background areas. This has the effect of destroying the unity of the engraving. I am apparently going to contradict this advice in one of the examples shown here. In the first branch design, the branches are defined by an 'implied outline' created by the surrounding horizontal tint lines. The resulting branch shapes are clear enough, but not razor sharp. In the other example you will notice a very fine outline used to give a crisp edge to the branches. The outline (made with a fine tint tool or spitsticker) is just enough to give a hard edge, but not so much that it separates the branches from the background. One is not better than the other; each has its own

use within an engraving. Should you want the shape to be less prominent and sit back, an implied outline can work better than a shape defined by a fine outline. Look at examples of Monica Poole's work for both approaches. And for the 'implied outline', look at Timothy Cole's engravings, in which shapes seamlessly morph into each other, or Richard Wagener for a more modern approach.

A similar branch shape can be engraved as a silhouetted form with the surrounding area cleared away completely. You will quickly realise that this black line engraving is vastly more time consuming than white line work, but nearly all engraving contains both methods of working. A methodical approach is the secret to clearing and this will show in the print. Always remember the practice of putting a piece of thin card under the tool to prevent bruising the edge that you are working away from.

Zigzag

To complete the block, have some fun with a graver and make a zigzag pattern as follows.

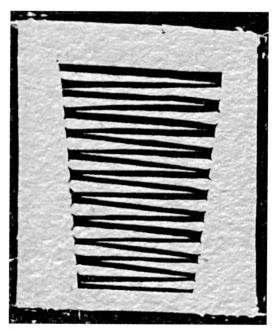
Zigzag.

Draw a black border and the overall shape of the pattern you are going to make. Then clear away the white area. Lay down a set of the above lines with a graver going from fine to broad, equal distance apart, then flip the block around on the sandbag and engrave between them in the other direction – the result is a pleasing zigzag pattern.

THE MULTIPLE TOOL

This tool requires special, separate attention. As I have already mentioned, every book on engraving that I have read either dismisses the use of the tool or urges caution. I think it embodies the principle that an effect easily pulled off is probably shallow and slick. With time and practice your engraving will come naturally, but the alluring and instant gratification from a set of lines magically engraved in one move is a cheap trick. I was tempted to give little more than a passing mention of the tool so as not to encourage its use, but there are ways of using the multiple tool in creative ways.

The first thing you will discover when trying to lay down an even area of tone with a multiple tool is that it is an impossible task. No matter how skilled you are you cannot keep the tool consistently flat (top right). Nor can you make second and third passes of the tool with even spacing. That kind of precision was only possible when the tool was used in one of the nineteenth-century ruling machines. Once you resign yourself to the impossibility of trying to be a ruling machine,

it is possible to use the tool in other, more creative ways.

A far better way of creating tone is to overlap arcs, rotating the block on the sandbag. In this way you can modulate tones by increasing overlaps (top line, middle). The tool becomes a paintbrush, putting down lighter and lighter strokes until the required tone is reached.

Next is a technique (top left) that I have used in many of my engravings. The above overlapping strokes can be made on top of a pattern of engraving to modify tone and sculpt form. This technique of knocking back tone on an already engraved form can also be made by simply hatching a set of diagonal lines with a tint tool, spitsticker or graver. In the example here, tonal variation is introduced in the foliage with good effect.

The marks in the bottom right section are achieved by rocking the tool from side to side as you advance it through the wood.

The swirling marks (bottom middle) can be combined with stippling for lovely smokey textures.

The last section (bottom left) shows the multiple tool used for a basketweave texture and the same texture arrived at using a tint tool. There is more artistry in the tint tool.

SUMMARY

I hope that engraving the sampler blocks has whetted your appetite for the medium. In the following chapters I describe the way I have approached a number of small engravings using various subject matter.

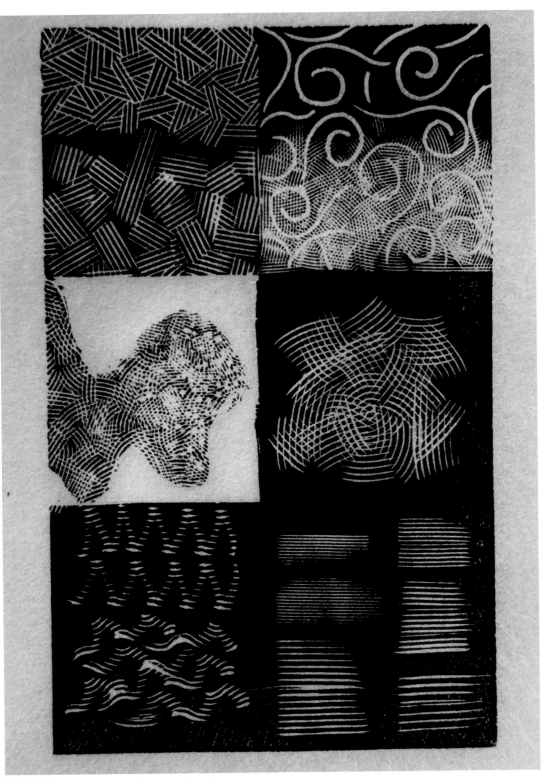

Sampler block showing uses of the multiple tool.

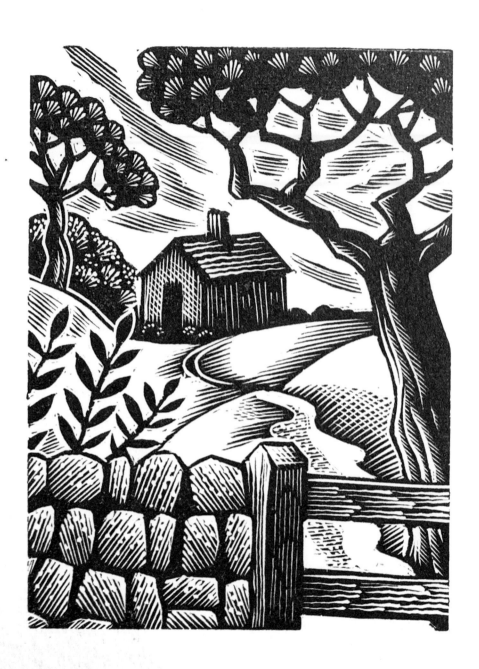

LANDSCAPES

Landscape is probably the most common theme for a wood engraving, in particular the English landscape. Those who confess to not know what a wood engraving is will recognise the medium from their jar of organic jam or biscuits, or maybe their favourite single malt. Often these images are not the real thing but imitative renderings in pen and ink or scraperboard. As someone who spent many years scratching a living as a freelance illustrator, I have been involved with creative directors in advertising agencies commissioning such illustrations 'in your pen and ink style'. These people knew the style of image they wanted for a particular product, but almost never understood that the image was laboriously engraved on a precious block of endgrain and printed in the age-old manner on a platen press. Not wanting to complain, it serves to keep wood engraving in the public eye, even when it is not wood engraving.

If you look at a Constable pencil sketch you can see that a landscape full of drama is present with a minimum of pencil strokes describing sky and trees. Lightness, silvery tones and atmosphere can be effortlessly created using a pencil. Students new to engraving often bring drawings of landscapes as the basis for their planned prints. I must break it to them that expanses of sky, sea and fields are the most challenging of subjects for the engraver. They can be handled, but with difficulty by a beginner.

LANDSCAPE WITH GATE, CHRIS DAUNT

My preliminary drawing was made on a mid-tone tan paper and the landscape was entirely imaginary.

Consider an example of a simple landscape engraving to understand my own method. This engraving was from imagination and was designed to show that a composition is easier to engrave when there are lots of elements filling the spaces. These elements – wall, gate, trees, building, plants – all make up a lively composition of positive shapes with the negative shapes between them.

Here I engraved the outlines of these shapes, using a medium tint tool (though you could also use a spitsticker). This is a straightforward first task and I usually suggest this to students if

◀ *Landscape with Gate*, 76 × 60mm.

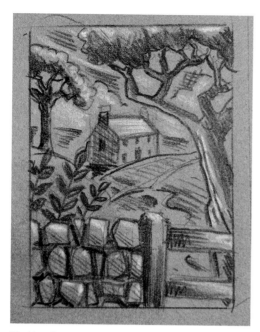

Working drawing on toned paper.

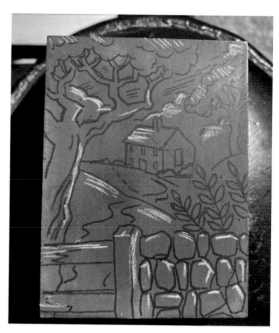

Carbon transfer drawing supplemented with white pencil highlights.

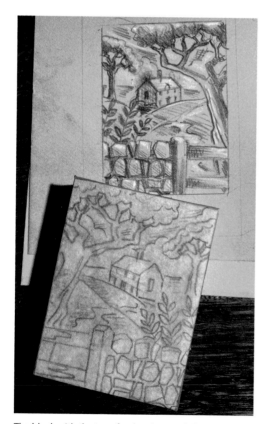

The block with the transfer drawing ready for tracing.

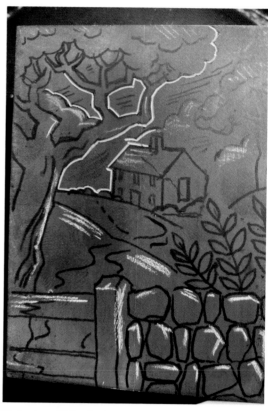

First cuts, outlining the trees.

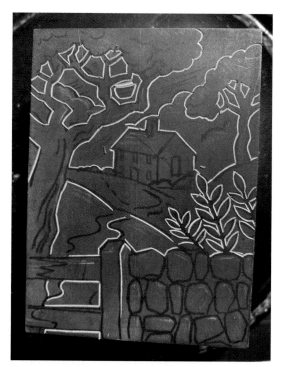

Outlining objects that will have a white 'halo' surrounding them.

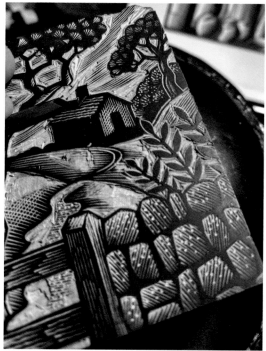

The detail and texturing here is simple and graphic in manner.

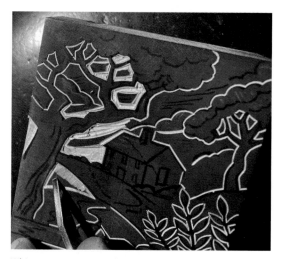

White areas are removed with a medium or large scorper.

their composition lends itself to this approach. As it happens, I try to steer their drawings in this direction, since I know that this is a way of engraving that is manageable and gives good results.

Once the shapes are established like this, the white spaces between are taken out with a scorper, leaving solid black silhouetted shapes into which you can work with tone and texture. As you can see in the photographs, I have a piece of card beneath the tool when clearing out the white areas to prevent bruising.

Even the wispy clouds in this example started life as solid black shapes, into which I cut curved parallel lines with a spitsticker, feathering them off at the edges to make them disappear into the white. These white areas between sky and branches are known as haloes and give a pleasing clarity to the image, creating an engraving that that has no pretence to realism.

The stone wall is very simply expressed. Each stone is a clear, defined shape surrounded by black boundaries. Only the upper edges have highlights, into which diagonal hatching disappears. To give the stones a granular texture,

The use of stippling over the linear marks produces a granular texture.

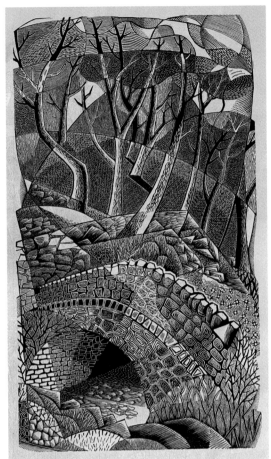

The Bridge at Aira Force, 175 × 300mm.

I added a smattering of stippling using a small round scorper.

The gatepost is in strong light and shade, giving it solidity and is engraved with a few vertical lines, fine in the shadow and broad in the light. The bars of the gate have a wood-grain texture, for which I used a medium graver and put a wiggle on the lines as they moved from fine to broad. For the trees I left them predominately black to suggest strength, with a little modelling where they catch the light. The tree foliage is greatly simplified with a hint of shape given by way of fan-shaped marks with a small graver or spitsticker. I hope it is clear from this example how important it is to master the manoeuvre of making a line move from thin to thick.

THE BRIDGE AT AIRA FORCE, CHRIS DAUNT

This is a large engraving on maple and depicts the spot where it is believed William Wordsworth found inspiration for the poem 'Daffodils'. I made a drawing of the area while staying in the area for a few days.

As can be seen, I superimposed dynamic lines across the drawing, dividing it up into a patchwork. I did this to impose an order on what appeared in front of me as a chaotic tangle of trees, foliage, rocks and sections of sky. I like this quotation from Balzac regarding what I was trying to achieve here: 'It is not the mission of art to copy nature, but to express it'. I like to think that artists are people who can see and draw out order and pattern from that which looks random and without structure to the casual observer.

The mark-making here tends towards the abstract but is suggestive of the various textures of rock, grasses, trees and sky. At the drawing stage I had no idea of how I would engrave the elements, only the composition.

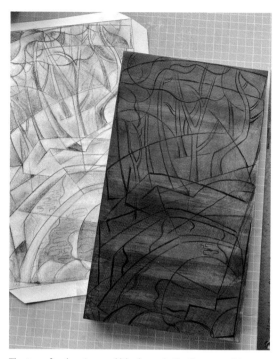

The transfer drawing and block – only the linear work has been traced, then worked over with brush and ink.

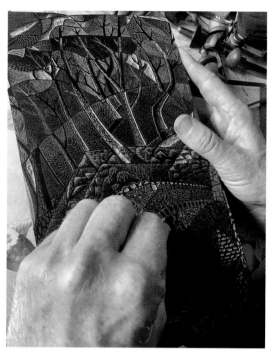

The photograph suggests that I worked from the top down. In reality I left the bridge until last because I could not decide how to do it.

The marks were invented as I went along. I enjoyed improvising to arrive at patterns that suggested the textures in the landscape.

The reveal is always an exciting moment, even after decades of engraving.

OUTLOOK JUNIPER, RICHARD WAGENER

Like much of Richard's work this engraving leans towards the abstract. The tree is like a monument, with sculptural grandeur against a stark sky. Wonderfully precise cutting throughout the engraving.

'This old Western Juniper was found on a glacier-polished granite outcropping in Yosemite National Park, California. I find it so impressive that such a massive tree can be surviving in an environment with such limited resources.'

Detail from *Outlook Juniper*. Each cut is perfectly considered – not a single line is out of place.

LEWESDON, HOWARD PHIPPS

This is a very clean engraving and worth studying as a way of tackling the challenging matter of trees against sky. The mesh of branches is set against a white sky, and the lower portion is rendered in even lines broken

Outlook Juniper, Richard Wagener, 127 × 73mm.

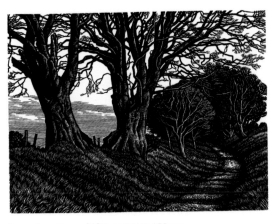

Lewesdon, Howard Phipps, 115 × 150mm.

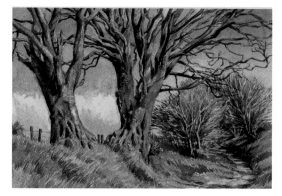

Howard's watercolour study, the basis for the engraving. Colour must be transposed into tone.

area of the engraving is given equal attention and not a mark is ill considered.

Howard has supplied his original watercolour painting as a way of understanding his approach.

SALTERSFORD, A MOORLAND FARM,
HOWARD PHIPPS

I often refer to Howard's landscape engraving when teaching. The majority of students chose landscape as their subject and there is no better engraver to refer to for study than Howard Phipps. The drawing is precise and every element in the design thought out. Lights and darks are pitched against each other and his mark-making perfectly describes surface and form. *Saltersford* is an engraving feast for the eyes.

up with cloud shapes. This is simple but convincing. The grassy banks are clusters of curved spitsticker marks varying in weight, length and proximity, with black gaps to define shadows. The path has a granular texture from stippled marks, broken up by shadows. Each

Saltersford, Howard Phipps, 100 × 125mm. Detail from *Saltersford.* Nothing is outlined in this manner of engraving, edges being created by the ending of lines. Beginners can learn a great deal by studying the rendering of all the elements of landscape in this beautiful engraving.

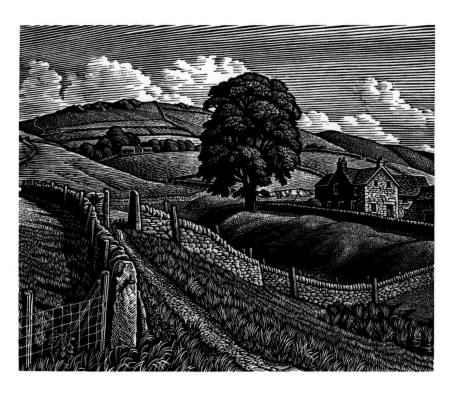

ORNAMENTAL, TONY DREHFAL

Tony Drehfal is an American engraver whose work draws upon the natural world in his native Wisconsin. *Ornamental* shows a wide range of tones and layers, where the leaves come forward or sit back according to how light or dark they are. Areas of white sky in the centre lend depth and definition to the foliage.

Often an idea for a wood engraving will percolate in my mind for years. During autumn walks in nearby woods I would see fallen leaves caught on low branches, hanging like ornaments on a Christmas tree. I often took individual portraits of these leaves with my camera, amassing quite a collection. With 'Ornamental' I focused on engraving the leaves' textures, working light against dark and vice versa, and cutting more swirling windblown tints.

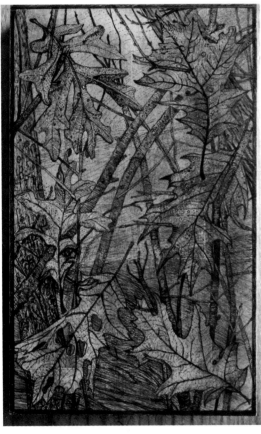

Drawing on the block. The tonal ground is a pale grey, which allows for greater visibility of such a detailed drawing.

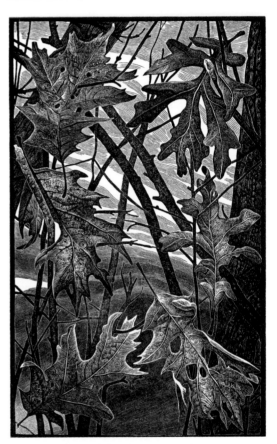

Ornamental, Tony Drehfal, 126 × 202mm. The most commonplace subject can be the raw material for a successful image.

LOVER'S LEAP,
DAVID ROBERTSON

Lover's Leap *is an incredible millstone grit formation at Brimham Rocks in Yorkshire. It is often referred to as 'The Chimney' by climbers. As you stand below these huge, weighty rocks precariously balanced above you, it gives you a very uncomfortable feeling. The affectionate name Lover's Leap comes from a folklore tale about a young couple and their quest for marriage. I generally walk the same route many times, getting to know the feel of a place before I start drawing. Back in the studio, I transfer a loose drawing to the block and then work very quickly. With gritstone formations, I marked only where the eroded recesses cast defining shadows and where the protruding areas catch the light. I translate the rest of the tones more freely in my signature stippling.*

Stippling works well to describe stone, but it cannot be random. Here the structure and shadows of the rocks are modelled with precision.

Lover's Leap, David Robertson, 170 × 140mm.

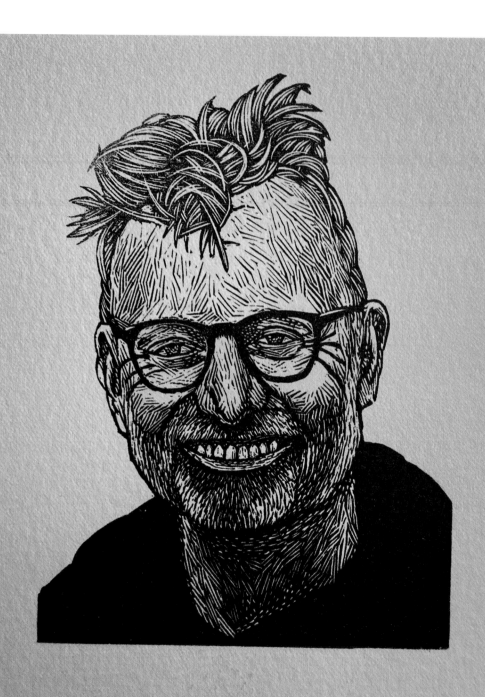

PORTRAITS AND FIGURES

Portraits always present a challenge in the way that landscape, still life and to some extent animals do not – they will be scrutinised for likeness to the sitter more than other subjects. That is the challenge, and if you are not deterred by it then let us look at the elements in this example.

HUGH DENNIS, CHRIS DAUNT

A portrait of the comedian and actor Hugh Dennis. I made this as part of the Channel 4 series *The Great British Dig*, in which Hugh Dennis visits various properties of note with a team of archaeologists. On this occasion the National Trust property, Cherryburn, was chosen. Cherryburn is the Tyne Valley birthplace of the great wood engraver Thomas Bewick and here Hugh embarked with me on a two-hour class in engraving. At the end of it I surprised him with this portrait.

Drawing
In this instance the basis for the initial drawing was a photograph: once I had made an outline drawing. I began to bring out the

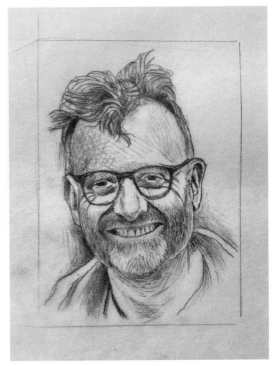

Drawing based on a photograph. The outline of the block is always the starting point. All the information I wanted is present here.

structure of the hair, making sure that each strand had direction. I also worked on the beard to make the lie of the hair follow the form of the face. The teeth show, something I

◀ Portrait of Hugh Dennis, Chris Daunt, 95 × 65mm.

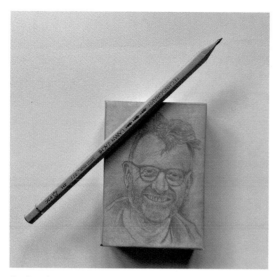

Outline drawing on the block, ready for tracing.

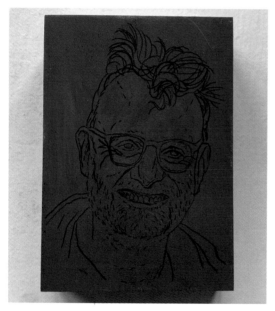

The black carbon line shows up clearly on the blue gouache ground.

had not had much experience with, and they needed to look convincing and in proportion. Eyes must align, so I took as much time and care as needed to get this right. The glasses also needed to align.

The next stage was to transfer the drawing using the carbon paper tracing method (*see* section on this in Chapter 2, Basic Procedures).

Engraving

There are numerous elements to consider here, and I will break them down, starting with the background. There is actually not one in this case, but that does not mean there is not a job involved. Removing a background so that the image floats is a task that can take as much time as an engraved background. In fact, you may assume that if something is quick and easy in a pencil drawing, it will probably be a lengthy slog in engraving.

To begin with, I outlined the shape of the head and shoulders with a large spitsticker (a large tint tool would also be good). This tool gives a pronounced outline and is still capable of precise contouring. This outline was then

The first task was to outline the head and shoulders before clearing the background.

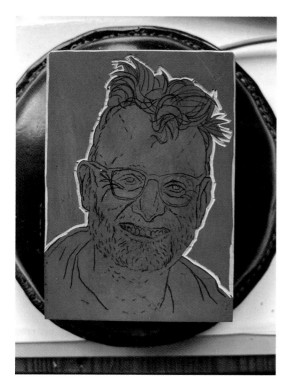

Opening up the outline with a round scorper.

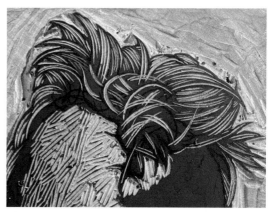

The hair has clear structure.

Clearing the background with a large scorper. This is a challenging technique.

Opening up the outline with a round scorper.

opened up with a small or medium round scorper before taking out the entire background with a large round scorper. The edges and corners were then chamfered with a chisel tool, which was also used to pare off the ridges left by the round scorper.

Since I decided that the shoulder area would be a plain black silhouette, this remained untouched. At this stage the face, too, was just a black shape showing the carbon tracing. I began by tackling the hair using a medium spitsticker to make curved lines varying in weight to describe each lock of hair. Notice how they overlap and form a lattice pattern in places.

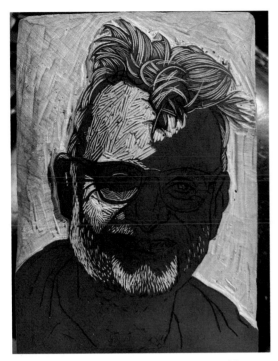

Modelling of the face using a set of varying line widths.

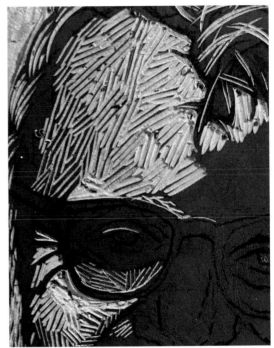

Detail of modelling of face.

I find it best to finish off one area before moving to another.

The method of engraving to describe the face needed to be carefully considered and there were several options. One was to make the lines of shading follow the forms of the face. This is rather difficult and too much of a challenge for a novice engraver. Another could be crosshatching, but for a portrait like this it would have looked too stylised and mechanical. I settled on using directional sets of lines using different tool widths to achieve tonal variation. For this I used different width tint tools. In this way it was possible to model the form section by section without having to precisely guide and control a contouring line, as would have been the case with the first method I alluded to.

At those areas where the beard grows, I used a medium spitsticker to make marks like this. By using a short scooping action these small marks, with a tapered start and finish,

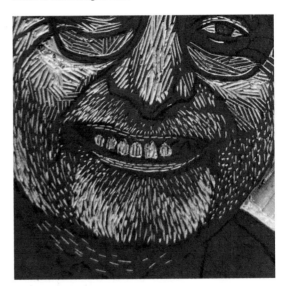

The short marks used for the beard follow the form of the face.

are well suited to the texture of a beard. Note that these marks are directional and follow the form of the face. This is important. Look at Thomas Bewick's masterly engravings of fur and

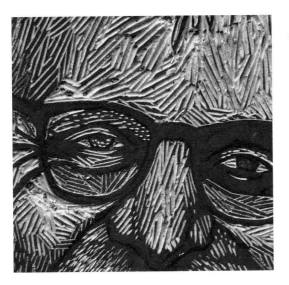

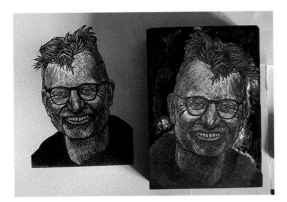

Finished print with block.

PORTRAIT OF ANA AKHMATOVA, CHRIS DAUNT

I wanted this portrait to be dramatic and to capture the feeling of the original brush drawing I made from a photograph of the Russian poet. In order to preserve the freshness of the original I scanned it into the computer and printed it out on waxed paper. This does not allow the inkjet ink to dry (it will not work with a laser printer) and readily transfers it to the engraving block. In order to do this, I placed the inkjet transfer sheet face up on the bed of the press and very carefully positioned the block onto the paper. It is vital to do this with the utmost care and a steady hand, because as soon as the block touches the image, it transfers – there are no second chances. I tone the block first and with a slightly lighter shade than normal because the inkjet transfer is grey rather than black. Your image on the block will be offset and permanent and was the perfect solution to the preservation of my original brush drawing. A feature of this engraving is the areas of solid black and pure whites.

Portrait of Ana Akhmatova, Chris Daunt, 90 × 100mm. In this engraving I wanted to transpose a brush and wash drawing into the medium of wood engraving.

feathers to see the same process. Not only are these marks following and describing the form, but they also vary in weight, that is finer and therefore darker where shadow is called for and broader in the lighter tonal areas.

I did not want the spectacle rims to alter the trajectory of the lines on the face. Looking closely, you will see that I have engraved a very fine, hardly visible outline around the rims. In some situations it makes for better engraving to define an edge without outlining and, instead, letting the surrounding area define the shape.

PORTRAIT OF ROBERT FROST, CHRIS DAUNT

Another engraving made using a wax paper transfer to capture the feel of the original brush painting. This was a multi-block engraving printed in several colours, but I also made a monochrome multi-block print.

A *Portrait of Robert Frost*, Chris Daunt, 90 × 120mm.

Similar in approach to the Akhmatova portrait, but a multi-block colour engraving which has the feel of a painting yet clearly shows marks made by engraving tools. Ink and chalk drawing used as a transfer image.

MAGDA WITH HEARTS, CHRIS DAUNT

A portrait of my daughter aged about ten. The original was from drawings made from life as well as a photograph. A large proportion of the image is Magda's hair, which I painstakingly engraved strand by strand following the traced lines. Note that not every hair was traced down, rather the strands in groups. Although the lines are fluid and 'on track', it should be said that they were engraved slowly and incrementally, without any loss of flow. Because of the concentration involved, progress was slow.

The other notable aspect of this portrait is the surface pattern on the skin, which is a method of 'knocking back' tone by means of hatching on top of an existing pattern of marks. The face is made up of a pattern of hearts which I then lightened and modelled with a multiple tool to achieve the desired tone and form. In order to avoid a mechanical appearance, I used the tool by overlapping in arcs until there were no solid areas of wood left.

It was with this engraving that I developed the method of modelling over engraved shapes with a multiple tool to model form.

Magda with Hearts, Chris Daunt, 100 × 145mm. I think it took me three days to engrave the hair with painstaking concentration.

HARRY BROCKWAY

Harry is an engraver and stone carver. His engraved figures usually have a monumental quality reflecting his work in stone, and they are instantly recognisable because of this. Here are two engravings of potters at work done for John Leach's Pottery in Muchelney, Somerset to help celebrate their 50th anniversary. They were engraved on lemonwood. The powerful presence of these figures suggests a larger scale and the way they fill the frame conveys intense physical work. Notice that there are no outlines at all – all edges are defined by the marks surrounding a figure or object. This gives a unity to the image and is very pleasing to the eye where lights and darks are played against each other.

The other striking aspect of Harry's engraving is the mark-making, where lines are rarely present and, when they are, they consist of long undulating dashes often made with a scorper. The technique is that of 'engraving backwards' as Harry puts it. By pushing the tool so far forward, then backwards to reveal the mark, the tool does not obscure the mark just made.

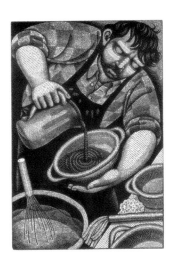

Glazing, by Harry Brockway
100 × 145 mm.

Throwing, by Harry Brockway.

Transfer drawing for *Glazing*.

SIMON BRETT

Simon Brett is one of the most significant wood engravers of our time. He has illustrated numerous books with his engravings and written extensively on the medium. Simon is a former chairman of The Society of Wood Engravers.

Three Torsos, Simon Brett, 200 × 250mm. Simon's command of the human figure in action is extraordinary. Some engravers bring graphic or design experience to the medium, Simon brings a painter's hand to wood engraving.

Pushkin, by Simon Brett. This is a bold engraving, economic and loose in style. It has the feel of a portrait made with the sitter in front of the artist. One third of the block is untouched wood, one third lively stippling, and the other describes the planes and features of the face in broad strokes.

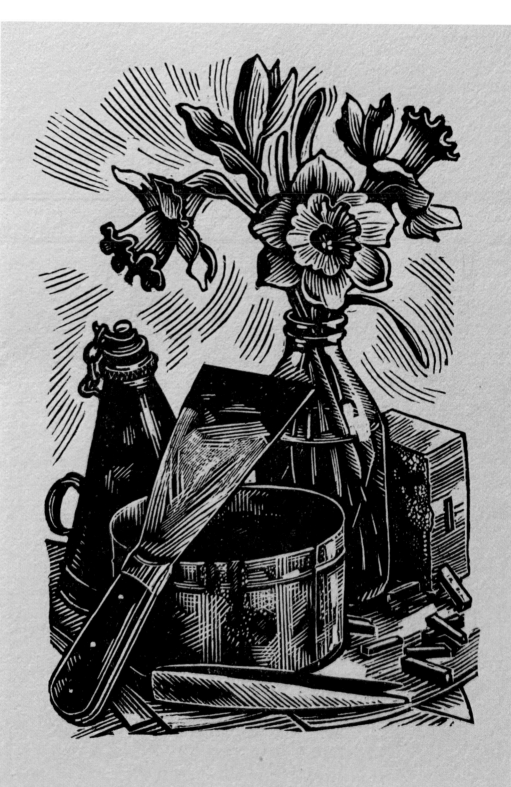

STILL LIFE AND INTERIORS

I find it surprising that there are not more still life engravings. Engravers, especially beginners, often engrave a flower, a feather, a nest, but rarely an arranged still life tableau favoured by the Dutch masters all the way to the Cubists. As subject matter the still life has lots to recommend it. Unlike a person or a dog, an arrangement of crockery and cloth is not going to become restless and move while you are drawing it. As a subject matter for developing drawing skills, the still life was time-honoured in the old drawing academies. You are free to arrange the group just as you want it, as well as the direction and quality of light.

Window Scene, Chris Daunt, 100 × 100mm.

WINDOW SCENE, CHRIS DAUNT

The image has been organised as a series of flattened planes with more attention given to the arrangement of shapes, tones and different textures. In a sense this is an elaboration of the sampler blocks in the earlier section of the book. The drawing shows a fully worked-out composition with tonal shading. Over many years of teaching, I have noticed that students often concern themselves with how they will engrave marks while they are still drawing the image. I can understand this, but it is best to avoid jumping ahead. Arriving at a satisfactory composition in which you are happy with all the elements (remembering that once you have started engraving, changes are too late) as well as tonal values, is all that should concern you.

◀ *Still Life*, Miriam Magregor 50 × 75mm. This is a beautiful example of clear and decisive engraving by one of the finest engravers of our time. It is a 'floating' image with no defined edges and a background consisting of sweeping lines surrounding the objects. These marks give energy to the arrangement but note that they are not the same as the ridges that one regularly sees in a linocut, which have an accidental quality.

The dotted lines in the drawing indicate the boundaries of a tonal zone.

The white areas have been cleared and I have moved from section to section as the mood took me. Whether you complete one section at a time or jump from one place to another is your decision.

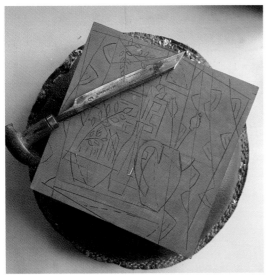

The first cut is always a momentous step. The block is prepared and the drawing calls out for you to begin.

It is very useful to work with a tonal schema of five or six values from solid black to pure white. If you indicate these zones in the drawing, you can then work between the two polarities with your greys. You will notice in the drawing that I use a dotted line to indicate a tonal shift and I trace this on to the block along with the

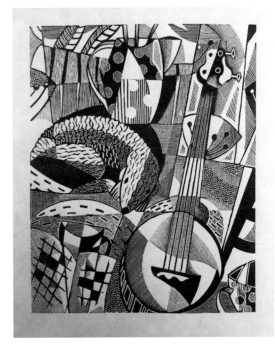

Woody and Banjo, Chris Daunt, 150 × 120mm. Here, I started experimenting and drawing what was in front of me in a cubist manner. We all know what they were trying to do, and I had great fun flattening the picture plane and playing with textures.

Detail showing a patchwork of mark-making. The original idea was a two-colour engraving, but it also works as a single block, black and white engraving.

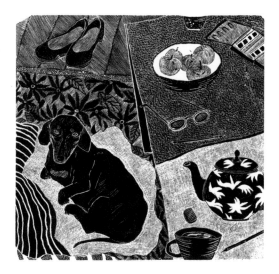

Autumn Apples and Dog, Sally Hands, 120 × 125 mm. Sally is a highly original wood engraver. Her work evokes painters like Pierre Bonnard, in subject matter and composition. *'I prefer to draw from life but this was a lockdown engraving of my friend's dog. I don't like working from photos and got him to send me a video of her so I got a sense of how she moved as well as close-ups of her face. It was September and the house was full of apples from the garden so I composed a still life around her'.*

Stones, Weimin He, 49 × 53mm. A remarkable first engraving by the Chinese artist Weimin He. Weimin is an accomplished artist who attended one of my engraving courses at the Thomas Bewick birthplace, Cherryburn in the Tyne Valley. On the first day students were invited to do a walk in the surrounding landscape to gather inspiration for their engraving. Weimin returned with a pocket full of pebbles from the riverside bank and produced this excellent still life.

shading on the block to see what works best for you. I often start by taking out at least some of the white areas as this immediately sets up the tonal range. Cutting an area, or areas of white, also makes the fear of starting easier to manage. This is a practice not limited to beginners. Working in this non-naturalistic manner is liberating because it allows you to enjoy the pleasure of mark-making and not be concerned about making the subject look real. Instead, your composition can be about a balance of lights and darks, shifting planes and textures. Shadows and the way light falls on objects are used to serve your composition and can follow your rules.

After making a few engravings you will find that you can quite easily deconstruct any engraving that is put before you – the marks made are there to see, nothing lurks beneath the surface, like layers of underpainting in an

outlines of the forms. I do not often make a shaded drawing on the block, though some engravers do. I suggest starting with the method I used here as well as experimenting with some

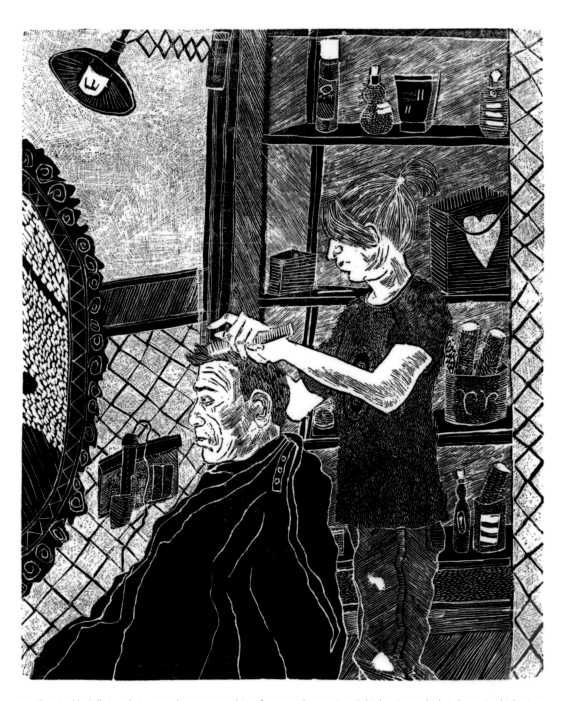

In a Glass Darkly, Sally Hands. Here we have a rare subject for a wood engraving. *'I think going to the hairdresser is a bit boring so I always take my sketchbook – especially as she has two lively, big dogs who are fun to draw. This time I drew my husband getting his hair cut, doing many small sketches, particularly of her hands. I had many small drawings which I took home and combined and also took a photo of the wallpaper which added to the busyness'.*

oil painting. You can also make good guesses at how the artist might have proceeded with their image. Here, for example (p.74), I would say that Miriam cut the outline shapes around the top part of the arrangement, then cleared away the white areas. Regarding the daffodils, notice that the treatment is quite simple, areas of black and white and a mix of black-line and white-line engraving. The former is where white predominates leaving black lines, the latter where white lines emerge from black.

When the drawing is strong, as it is here, the engraving can be simple and understated where a few well placed marks go a long way to describe form and surface.

A page from Sally's sketchbook. Sally never works from photographs.

This is a Wood Engraving, Pete Lawrence, 190 × 230mm. Refreshingly humorous two-colour engraving, which only those on the inside will appreciate. Wood engravers may get offended when their art is referred to as a woodcut, while Magritte liked to throw in a bit of philosophy.

BUILDINGS

Unless your buildings feature in an abstracted design where perspective is thrown to the wind and sacrificed for a dynamic composition, then you need to spend time getting them to follow such rules. Making the lines converge to a vanishing point is not difficult and makes a big difference to the way your building looks. You also need to establish a direction of light and keep it consistent. Putting the building(s) in strong light and shade (chiaroscuro) will give them structure. A cast shadow will introduce another form to the area around the building and help anchor it to the ground. Floating buildings are never convincing.

Most structures are made from brick or stone with a tiled roof. One of your tasks is to find ways of not depicting every brick and every tile, yet still describe these elements. The answer is to simplify by finding a 'handwriting' that says brick or tile. Here are some ways to do this. One advantage of heightening the light and shade on the building is that you can bleach out most of the detail on the face in strong light, and merely hint at the detail in the area in shadow. Windows are most convincing when left black, a trick used by architectural artists.

Often a scene with buildings will be a real place, recognisable and therefore open to scrutiny by people who live there. The viewer will be perplexed if their house or street is a mirror image. So, you must engrave it in reverse. Do not panic: this is easier than it seems. Make your drawing on tracing paper, in the correct orientation, then simply flip it over before attaching to the block for tracing down. Alternatively, scan your drawing into the computer and 'flip horizontal' before printing out. This is the solution if you do not like drawing on tracing paper.

Once traced down onto the block, do not have any scruples about strengthening the lines of your building by drawing over them with a ruler. Do not worry, your trembling hand will ensure that the lines do not look mechanical. They will have pleasing undulations and, at the same time will be nicely horizontal, vertical or diagonal because of your ruled lines.

◀ Detail from *The White Horse 2*.

COUNTRY CHURCH, CHRIS DAUNT

A small engraving in a simple, graphic style made for teaching purposes. The style owes much to the late Derrick Harris. Complexity in nature can be expressed with simple methods of cutting and still convey texture and form convincingly. Stonework, roof tiles, foliage and clouds can be simplified in this way so that they become a pleasing arrangement of elements.

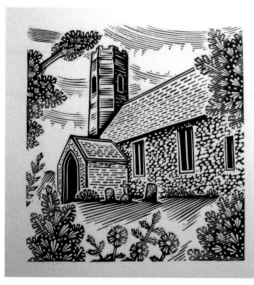

Country Church, Chris Daunt, 95 × 95mm. A stylised engraving after the manner of Derrick Harris.

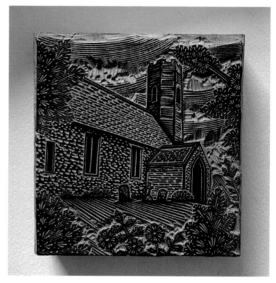

The engraving was made on a pearwood block. Pear is softer than boxwood and pleasant to engrave. It has a distinctive pink colouring.

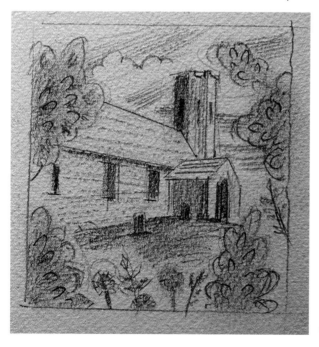

Rough drawing with the emphasis on simplicity and broad shapes. If the scene was a real one, it would be important to have the orientation correct by tracing down the drawing in reverse.

KATHMANDU ALLEY, RICHARD WAGENER

Richard is a master craftsman in his technique and there is much to be learnt from the study of his cutting. Notice, in all his engravings, that nothing is outlined, and edges are created by the precise ending of one area meeting another. A close look at this engraving shows a patchwork of surface textures that tends towards abstraction. The use of pure black shadow in the foreground is daring yet completely convincing.

'When we arrived in Kathmandu, 1995, the taxi turned onto ever-narrowing streets to take us to the guest house where we were staying. With stores on each side of the street and crowds of people it did not seem like we would make it through. In creating this image, I was thinking abstractly in stacking the rectangles of buildings framing the sky.'

Kathmandu Alley, Richard Wagener, 127 × 76mm. This detail shows how the artist has created a dramatic play of light and shadow using the black of the wood and carefully arranged blocks of texture.

Detail from *Kathmandu Alley*.

THE WHITE HORSE 2, PETER LAWRENCE

Pete Lawrence is one of the most original of contemporary engravers. Wood engraving in the popular mind is associated with bucolic scenery evoking past times, but here is nature presented in a very different manner, playful and full of surprises. From a technical point of view the cutting is masterly and the composition beautifully constructed.

'This is an attempt to combine realism and abstraction in one coherent image, unlike my 'collage-inspired' engravings which combine separate styles. The place is imaginary. There was no sketch – it began as a freehand cutting into a piece of black mountboard. Peeling off the top layer to give a bold black and white design. There are two horses, reminding me of both David Jones and Eric Ravilious.'

The White Horse 2, Pete Lawrence, 300 × 370mm. The viewer is led into the scene and has to work to unravel the elements. Buildings emerge then disappear into a board game.

Detail from *The White Horse 2.*

THE RENNIE ESTATE, LOUISE HAYWARD

Louise takes non-traditional subject matter for her inspiration, often blocks of social housing in the brutalist tradition of building. The Rennie Estate, blocks of flats on a post-war council estate in Rotherhithe, London, provides a subject that powerfully conveys the bleakness of the location with a foreboding sky lurking behind the flats. It has a drama that reminds me of a stage set for a play.

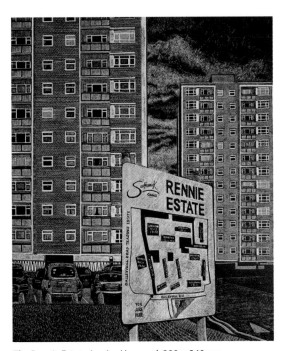

The Rennie Estate, Louise Hayward, 290 × 240mm.

BEDE AND JARROW, HILARY PAYNTER

A montage-style engraving successfully showing various elements of the history of Jarrow on Tyneside. Hilary is never afraid to tackle panoramic or diverse subjects and miraculously combines them in a single engraving. Note how the buildings are simplified yet full of varied textures. Hilary writes:

'Bede was pivotal to this whole area. The church at Jarrow and the monastery ruins were built with stone from the Roman wall and remain on the south side of the Tyne. The Jarrow marches link the ancient religious marches with the recent past and Bede's monument stands proud on Sunderland's seafront.'

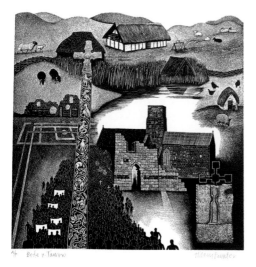

Bede and Jarrow, Hilary Paynter, 200 × 200mm.

CLOVELLY, HILARY PAYNTER

Hilary has very skilfully arranged the harbour and village into a magnificent, flowing composition.

'Clovelly is an extraordinary old village with no cars: all deliveries are made on wooden sledges. I have been fascinated with the place since my first visit to Devon and have tried to depict the way it nestles into a cleft in the steep rock face. I never had enough room on my page to complete the massive breakwater when I was sketching.'

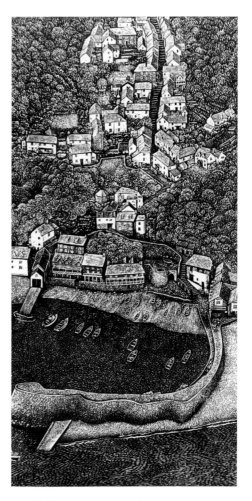

Clovelly, Hilary Paynter, 310 × 240mm.

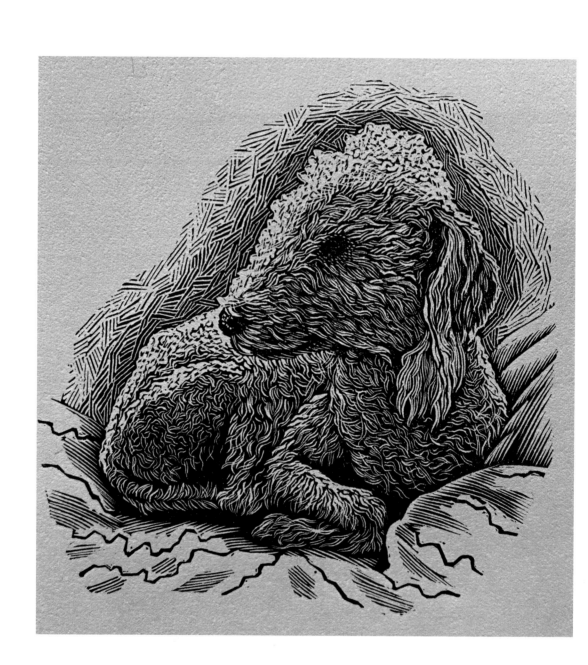

ANIMALS

H ere I include any creature that found its way into the Ark, though I will limit my selection to only a few, since experts think that Noah may have been joined by as many as 7,000 critters.

WOODY, CHRIS DAUNT

My beloved Bedlington Terrier, often mistaken for a sheep, appears in many of my engravings, much like the affectation of the Scottish painter, Graigie Aitchison. These dogs have been described as whippets in cotton wool.

In the first photograph you can see the original drawing next to the block in its early stages. The drawing is on toned paper with white pencilled highlights. The carbon tracing

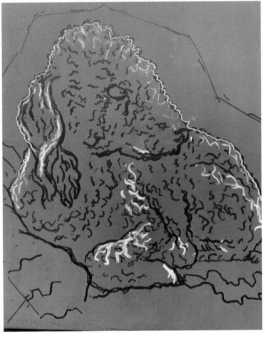

First cuts are usually outlining where this is appropriate. This is usually a good way to ease yourself into the engraving.

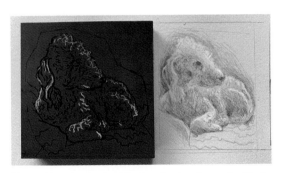

The working drawing and the transfer drawing on the block with white highlights.

◀ *Woody*, Chris Daunt, 100 × 100mm. The finished engraving – a floating image as an option to working with the square or rectangular shape of a block.

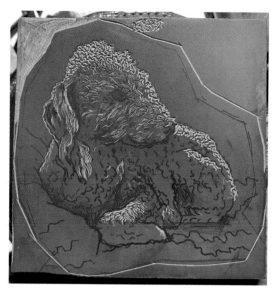

Working the light areas of the fur. Note my tester cuts in the part of the block that will be removed.

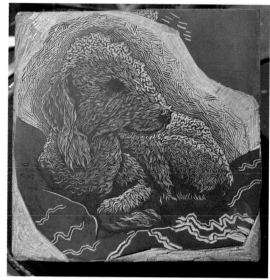

Showing the progression from light to dark on the dog. This movement from light to dark is a matter of personal preference – you may prefer the reverse.

on the block is less detailed than I would normally make, and I have added white pencil highlights on the blue/grey gouache ground.

I started by outlining a background shape and began the clearing process to remove wood around the shape. As this is tedious, my habit is to do a section until I get restless and move on to more interesting passages. I then began working on the lightest areas of the dog's hair. My method in engraving the hair was to use a progressively larger tool as I moved from the areas in shadow, through to those in the strongest light. The technique of making the S-shaped swirls was used to describe the lie of the hair on the forms of the body (study Bewick's methods for engraving fur and feathers). In the shadows I used a fine tool with the lines further apart. At the lightest, where the hair becomes a glow in the light, I used a broader tool (small round scorper) and left little wood around the marks. Once the engraving of the dog was complete, I moved to the backdrop shape and created a tone around the dog using sets of short straight lines in a basketweave

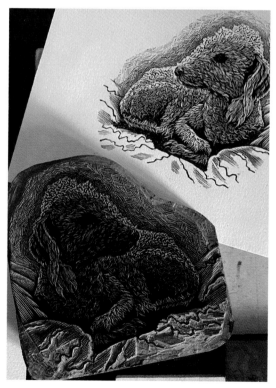

If you have access to a bandsaw, blocks can be cut to shape to save the time and work involved in clearing.

pattern. The patterning of these lines follows the same process as the body, that is, progressively lightening towards the edge using broader tools (broad white lines make for lighter tones). I then rendered the blanket using black-line engraving for the linear pattern and some closely set lines to suggest folds.

As you can see, the finished block has been trimmed to avoid doing an excessive amount of clearing. I am fortunate in that I have a bandsaw to do this.

THE BLACKBIRD, THOMAS BEWICK

Any discussion on the engraving of animals should refer to Thomas Bewick's *Quadrupeds* and *British Birds*. These volumes of illustrated natural history are important both in the history of wood engraving as well as for their depiction and description of four-legged creatures and birds. Both books were hugely popular in Bewick's own day due to the beauty and anatomical accuracy of the engravings, as well as the accompanying text giving highly detailed and informative descriptions of the creatures and their habits. As an aspiring engraver, I am not suggesting you try to imitate Bewick's style of work, which has to be understood in the context of his time. Wood engraving, as a style, grew out of copperplate engraving, and shows more than a passing resemblance to this medium. A close look at one of Bewick's engravings is worthwhile.

I have set Bewick's watercolour preliminary study alongside the engraving. Bewick often used watercolour for his studies, even though colour plays no part in the engraving. Comparing the two, you will see that it is only the bird that holds a close resemblance to the original drawing. The surrounding fore- and background only shows a nod to the drawing and once on the block Bewick felt no need to make a faithful copy. We can only speculate about how much drawing Bewick transferred to the block, but it seems to have been far less than the complete preliminary drawing. The method as described in John Jackson's *Treatise on Wood Engraving* indicates that a full tonal drawing was made in pencil on a block that had been given a slight tooth with a thin paste of pumice and water.

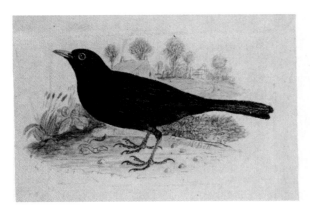 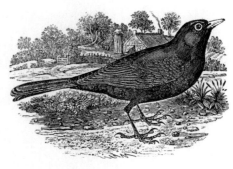

The Blackbird, Thomas Bewick, 185 × 55mm. Bewick's watercolour drawing and the resulting engraving. Bewick often based his engravings on his watercolours.

SONOMA HAWK,
RICHARD WAGENER

'This hawk was seen at a bird rescue centre in Santa Rosa, twenty miles north of where I live in northern California.'

A bird perched on a branch or ledge is one of the most frequent subjects to appear in a beginner's class. Almost always there is no background in the drawing and the reference is a photograph showing the bird in glorious colour. The feathered structure of a bird is something of a challenge to any engraver and this example shows how an artist can impose clarity on the subject and tone to replace colour. The background is a tour de force of engraving. Note the shift in tone in the lower half, achieved by using a narrower tool, and the frame.

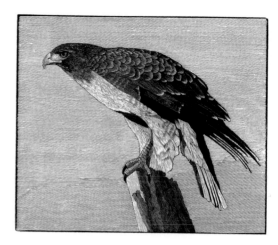

Sonoma Hawk, Richard Wagener, 95 × 114mm. In the tradition of Bewick, but with a distinctly modern feel due to the more formalised cutting.

WOODY ON THE PATIO,
CHRIS DAUNT

I made this engraving as a tribute to Monica Poole. Monica gave me guidance via letter in my early days as an engraver. She was keen that I did not 'bandage forms' (that is, make the lines follow the shape). Her method was to model shapes by means of straight line hatching. I chose not to follow her advice at the time, but did so 30 years later with this engraving. This is a hard-edged style with clearly defined tonal boundaries. The lighting is stark and dramatic.

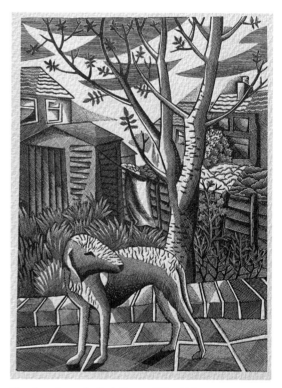

Woody on the patio, Chris Daunt, 17.5 × 12.5cm.

PEAKS SHEEPDOG, CHRIS DAUNT

A sheepdog, whose name I can no longer remember. We got along well and I made this engraving of her, based on a photograph. In the manner of Bewick, the dog is anchored to the earth with a shadow and set against a linear sky. An example of engraving where the background sky took much longer than the central image. The more you want something to sit back or drift into the background, the longer it will take you.

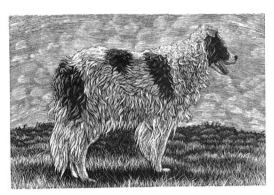

Peaks Sheepdog, Chris Daunt, 130 × 55mm. I avoided outlining the dog and created its shape from the surrounding engraving, which can be seen on close scrutiny.

PENGUIN ANDREW DAVIDSON

Andrew is one of the most highly regarded engravers/illustrators in the world. This beautiful, oval format engraving shows that the great tradition of Thomas Bewick lives on. The two majestic birds in the foreground are worth close study, as they show how the directional marks describe both the fine feathers as well as the form of creatures. The drawing is precise and assured. Note that the sky is shaded with great delicacy and detail yet sits back in the design. This takes much skill.

Since the majority of Andrew's engraved work is commercial he has to work at speed, yet still produces engravings of the highest quality.

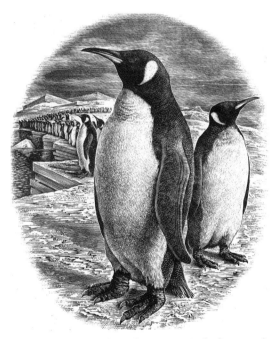

Penguin, Andrew Davidson. The penguins in the foreground are the most detailed, while the others recede until they are reduced to approximations.

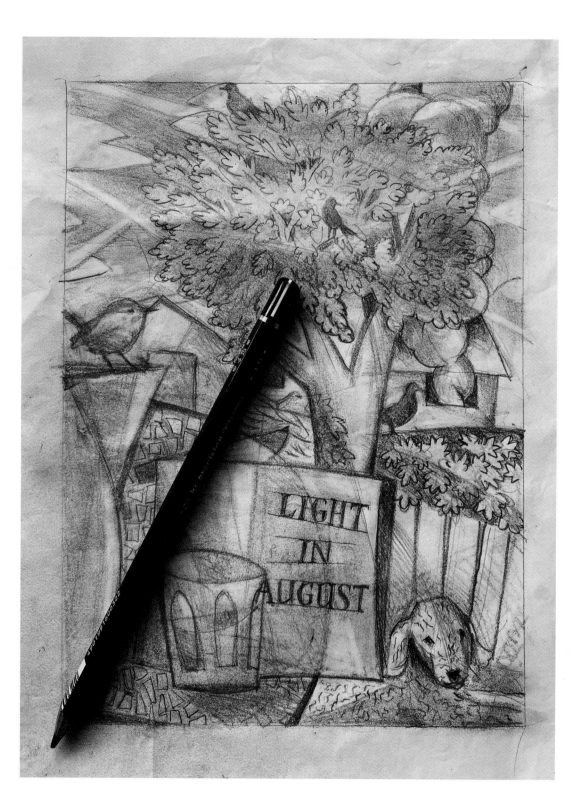

DRAWINGS AND ENGRAVINGS

In the nineteenth century an engraver would almost certainly not have thought of him- or herself as an artist, but rather as an artisan or even tradesman. The artist supplied the drawing by one means or another and the engraver engraved it. The engraver's role was to make a reprographic block that would allow for the production of multiple prints in books or magazines. We will never know how many of these highly skilled artisan engravers could draw well or were simply very skilled in the craft of engraving on wood.

Is there something that can be considered as a drawing for engraving, or will any kind of drawing serve as the basis for an engraving? The question to ask when drawing with an engraving in mind is what kind of information will be needed, especially if you are in the early stages of your engraving practice. I would suggest that the more information you put into the drawing the better. Since colour is not an element, you will be concerned with tone and texture and perhaps direction of light. You may discard or change some of the information when you come to engrave, but it is better to have more than you need. For some it might go against the grain to work in such a premeditated manner, but this medium is one of the least spontaneous.

Mistakes cannot be undone, engraved marks do not like being modified or reworked and, if you do so, the freshness of your engraving will be compromised. I once heard a student groan when I advised this level of careful preparation – she was a free spirit in her printmaking practice and this kind of planning did not sit comfortably with her. To her credit she conceded that I had given good advice when several areas of her engraving started to call out for information that was absent from her drawing and a foreground fence that did not have nearly enough precision.

WOODY AND BANJO, CHRIS DAUNT

Here is an example of my own work showing the origin of an engraving from the initial idea.

I was looking for a subject for a new engraving and decided that the scene in front of me was as good as any. I like to recall the catchphrase of the Irish comic Frank Carson 'It's not the joke, it's the way I tell 'em'. The subject matter is less important than the way you draw, paint or engrave it. I did not feel any obligation to copy what I saw in front of me – it was merely a starting point for a composition. At

one point the dog was asleep on the sofa, then he moved away. A beautiful yellow jug made by Michelle Johnson was in the kitchen and found its way into the picture. My morning coffee and crossword book were on the table and muscled their way into the scene. I then began to overlay geometric divisions and worked in tones and patterns loosely based on what I could see. I hope the enjoyment I had comes through in the engraving.

Initial idea/sketch for *Woody and Banjo*.

Progressing the drawing on toned paper.

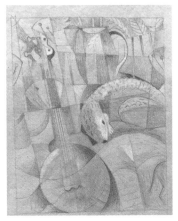

Drawing tightened up for transfer.

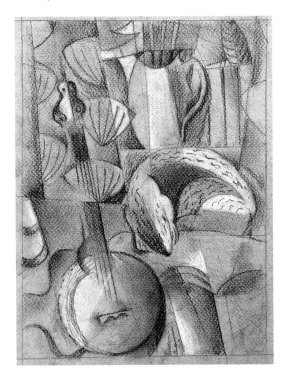

Drawing completed.

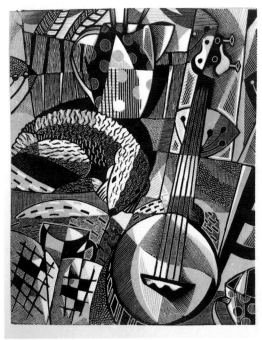

Woody and Banjo, Chris Daunt, 150 × 120mm two-colour engraving.

STANDING NUDE, CHRIS DAUNT

I once rented studio space in Newcastle, where a group of the artists hired a model for life drawing once a week. This was my first and only engraving based on such a life drawing and also my only entirely stippled engraving. The original drawing was very large and I made this smaller drawing from it as the basis for an engraving.

There is not a single line in the image – everything is defined and modelled by stippled tones. The success of this approach is dependent on the information in the drawing.

Rough drawing from life class.

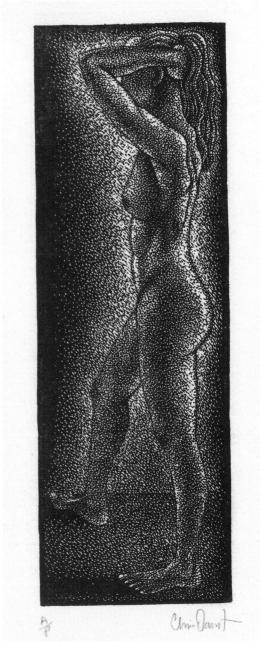

Standing Nude, Chris Daunt, 50 × 145mm.

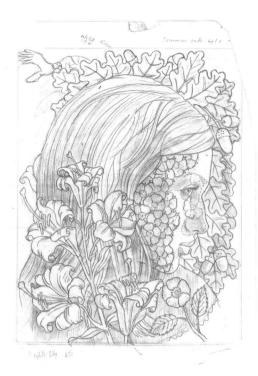

Tracing for the engraving.

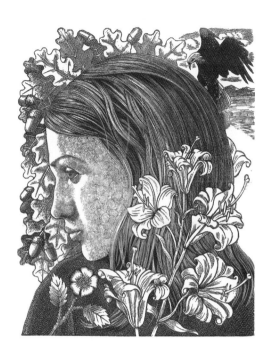

Magda with Flowers, Chris Daunt, 140 × 175mm.

MAGDA WITH FLOWERS,
CHRIS DAUNT

My first engraving after I stopped working as a commercial illustrator. Freed from the pressure of meeting unreasonable deadlines and dancing to someone else's tune, I could now engrave what I liked and take as much time doing it as it required. It was liberating. And I certainly took my time over this block, developing a method for modelling tone over pattern on the face. This engraving shows a balance of black line engraving in the foreground lilies and white line engraving in the face and hair.

The tracing shows the outlines that I transferred to the block, but my original tonal drawing is lost.

THE ORGANIST,
CHRIS DAUNT

As can be seen on the brush drawing, I drew red grid lines over it and used this traditional grid method for copying a drawing. Once it was on a lightly toned block, I used various dilutions of Indian ink to emulate the brush strokes of the drawing. The flowing, closely spaced lines of different weight were an effective way of suggesting brush strokes. This method is an alternative to the wax paper inkjet transfer method should you want to eschew technology. As long as you have the structural drawing in place you can be quite free with the brush.

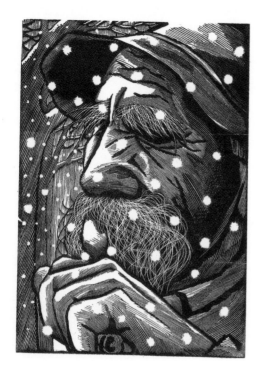

The Organist, Chris Daunt, 110 × 155mm.

MAGDA AS EMILY DICKINSON, CHRIS DAUNT

A whimsical interpretation of an Emily Dickinson poem '*The Way I Read A Letter's This*'.

I made a delicately shaded drawing with a plan to engrave something that would test my printing abilities to the limit. I based the portrait on a photograph and improvised the blouse and background and framed it in a cameo shape as a visual echo of the poem's theme of a private reverie.

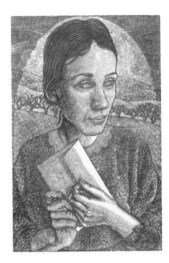

Magda as Emily Dickinson, Chris Daunt, 100 × 150mm.

Brush drawing.

Preliminary drawing with transfer grid lines showing.

THE YELLOW WALLPAPER, CHRIS DAUNT

This is the key block of a four-colour illustration I made for the short story by Charlotte Perkins Gilman. I often find that the key blocks of my colour engravings will stand on their own as black and white images.

The drawing is the one I used to trace down onto the block and the fine black lines of the pen I used as a tracing stylus can be seen. You can see the mitred side flaps and tape to secure the drawing to the block.

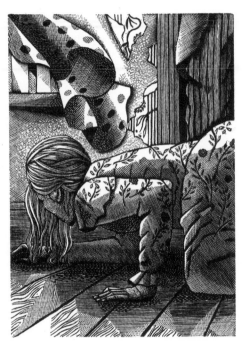

The Yellow Wallpaper, Chris Daunt, 100 × 140mm.

Transfer drawing.

MAGDA WITH CAT, CHRIS DAUNT

Finally, a full-colour, multi-block engraving. The drawing was a culmination of several rough drafts to arrive at the right composition. Once I had achieved this, I made a full-colour pencil drawing using the four colours plus black that I intended for the print. Once again, I used the grid copying method to put the drawing on the block. Only the linear structure was drawn onto the key block. Once engraved, I transferred the image from the key block to each subsequent colour block in order to accurately register the blocks with one another.

Colour engraving opens new worlds, but is beyond the scope of this volume.

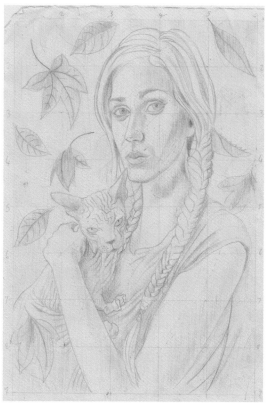

Colour drawing.

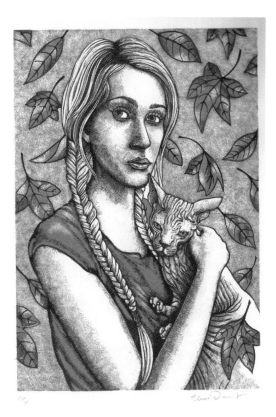

Magda with Cat, Chris Daunt, 150 × 220mm.

PRINTING

Your engraving will only be as good as your drawing. Furthermore, it will only be as good as your printing skills. In the nineteenth century, engraving was one trade and printing another. Only in the twentieth century did the engraver print his own work, and even then (and now) some engravers have their work editioned by a professional printer. That said, I consider it essential that you learn how to become the best printer you possibly can. I know some eminent engravers that confess to not liking the printing process, but nevertheless do it and do it well.

As a beginner you probably will not own a platen press such as an Albion or Columbian but may have access to one at a nearby print studio or college, where you can also get some tuition on the use of the press. Even so, you cannot be sure of getting more than very basic instruction for printing a wood engraving.

Layering damp sheets of printing paper between blotters.

DAMPENED PAPER

If you take the time and effort to condition printing paper by dampening, you will be well rewarded. Damp paper produces thoroughly softened fibres, making it receptive to the ink

and the block, allowing you to use less ink and still achieve dense, velvety blacks without compromising fine detail.

Not all papers like being dampened. As a rule, avoid dampening Japanese papers unless

Slide the damp sheets in a large bin bag and seal the end.

Place a heavy board on top – the heavier the better – and leave overnight.

they are thick, and even then, tread cautiously, as they are often held together with less size than European papers. Generally speaking, Japanese papers are soft enough to print on as they are. Ultra-smooth European papers with a calendared or glazed surface will lose their shiny surface when dampened. Waterleaf papers (unsized) such as Arches 88 should not be dampened.

Over the years I have consulted several respected printers on their method for conditioning paper before printing and the following procedure is the one I have settled on, based on their advice. Fill a tray or sink with water. If you have access to it, distilled water will be the purest, as it is stripped of the chemicals with which our tap water is contaminated. Pass a sheet of paper through the water and let the excess drip off before laying it on a sheet of thick blotting paper. Then alternate with dry and wet sheets. You could place two of these piles side by side on the blotter and finish by placing a blotter or two on the top. Wrap this bundle in a bin liner and seal the opening. Place on the floor or a table and put a board and/or heavy weights on top – the heavier the better – and leave overnight or longer. When you open the pack your sheets should feel cold when held to the cheek, but not soggy and will be ready to print.

I am convinced that once you have managed the level of moisture in the paper you will not go back to printing dry.

ROLLING OUT INK

Squeeze or scoop out a small amount of printing ink at the far end of the slab and spread it out evenly with a palette knife. Then take a roller of at least the same width of the block you are printing and roll out the ink thinly and evenly. The sound should be a gentle hiss and the appearance like fine velvet. Above all, take care

Spreading the ink with a palette knife to the width of the roller.

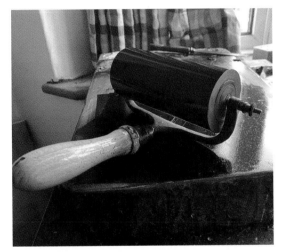
An old lithographic stone makes a very solid inking surface.

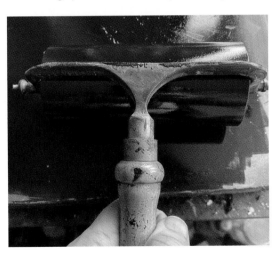
Rolling out the ink to a fine velvety texture.

not to apply too much ink to the block. You can always increase the ink level should the block print grey, but removing ink is a troublesome matter. If the ink on the slab is too thick, the texture will look like orange peel.

Using a stiff, oil-based relief ink, will mean you need to spend time rolling it out on a smooth inking slab. A sheet of thick glass or Perspex-type material makes a good surface. I use an old lithographic stone. There is a saying in the printing world that goes 'print with pressure, not ink'. Like most sayings, it exaggerates to make a point, but in the case of hand burnishing you will often need slightly more ink than for press work. A press will always exert heavier pressure than the hand. Even so, always go cautiously and use the least amount of ink to arrive at an optimal print. Only increase the ink levels very minimally, as too much ink will result in ink creeping into your finely worked lines.

PRINTING WITH A BURNISHER

Printing without a press is also possible using a burnisher and suitable papers. Although some people use European mould-made

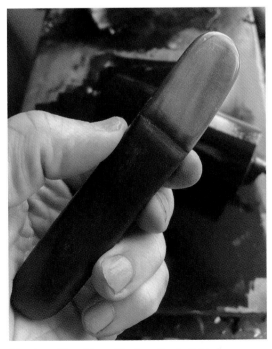
A hardwood burnisher with a horn tip. Available from my website.

Awagami papers, many of which are excellent for burnishing.

A rubber mat will prevent the block from moving around with the pressure of burnishing.

Feeling for the smooth side of the paper – nearly all papers have one side smoother than the other.

papers for burnishing, they are too heavy for the task. There are many high quality and very beautiful Japanese papers available that make the process so much easier than laboriously rubbing away on a thick paper. A paper that I highly recommend starting with is a lightweight Kozo in either white or natural shade. This is inexpensive, produces good prints and seems to be archival. Suppliers like T. N. Lawrence and Awagami sell sample books and packs of Japanese paper, making it easier to try out the array of papers available.

You can buy a purpose-made burnisher from my website. These are comfortable to hold and offer a flat burnishing surface with rounded off edges, making them a better choice than the back of a spoon. Spoons only transfer pressure at one small point, making it difficult to arrive at an even impression.

Place your block on a rubber mat to prevent it moving as you pass the ink-charged roller across it from end to end. Only light pressure is needed if you are using a brass-handled roller, slightly more if using a lighter model. If your block is small, you can hold it and roll up the ink. The best way to assess the inked block is to hold it up to the light and look for a consistent glisten from the ink – any uninked patches will show up dull.

Place the inked block back on the rubber mat. Hold the paper between thumb and forefinger to feel for the smoothest side and always use this. Then, carefully hover the piece of printing paper over the surface until you have it centred. Slowly lower the paper onto the block and let it drop and adhere (the ink acts as a glue). Once on the block, carefully press the paper down in the centre and this will secure it ready for burnishing. Because these Japanese papers are either transparent or translucent, you will see clearly where you have and have not burnished. For solid black areas a good amount of pressure is needed, and less for delicate linear passages. Experience will tell you how much pressure is needed, but probably

Thin Japanese papers are translucent, and this allows you to assess the progress of the burnishing.

more than you think at first. Areas of solid black require considerably more pressure than finely worked passages. Overall evenness is easy to assess from the reverse. Care needs to be taken as you approach the edges of the block, as it is easy to crease or tear the paper with a slip of the burnisher.

Pressing the paper onto the centre of the block.

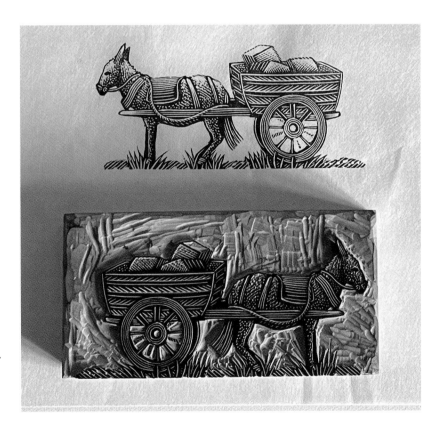

Burnished print and block. The results are usually as good as a press print, but much harder work with larger blocks.

Selective pressure is possible, meaning that you can give emphasis to passages, achieving what make-ready does on a press print. The challenge here is maintaining consistency throughout the edition. Fortunately, you can check the quality of your burnishing by peeling back the paper as you go and laying it back if an area is too light.

There are a few advantages in using a burnisher, aside from that of cost. Burnishers are small, light and portable and will give perfect results if used with smooth, thin Japanese papers. The disadvantages are that it is a more labour-intensive procedure than printing on a press, especially if your blocks are large and the edition is more than thirty or so prints. It is also challenging (but possible) to keep the prints consistent across the entire edition. This is especially the case if you employ variable pressure burnishing to achieve emphasis or delicacy of tone. However, if you master this, then you can rightly feel that burnishing leaves you at no disadvantage, other than being restricted to the use of thin Japanese papers.

PRINTING WITH A COPYING PRESS

These presses usually have a smaller printing area than platen presses, but the principles of printing with them are very similar. The first thing you need to do is to secure the press on your bench or table. The action of tightening the screw-down plate when printing will cause the press to move if it is not firmly held in place. One easy method is to make two L-shaped pieces of wood and screw them into the bench at two corners of the press.

You will need a base board made from heavy card or preferably plywood where the block and paper can be located. To serve the function of a tympan, various types of packing

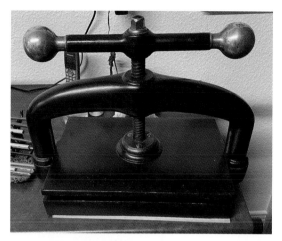

Printing with a copying press.

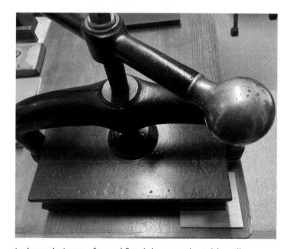

L-shaped pieces of wood fixed down to the table will ensure that the press remains firm when the screw is tightened.

can be used – either a pad of newsprint, or a sheet of rubber or vinyl. This can be either hinged or placed loosely over the inked block and paper to distribute evenly the pressure from the plate.

Once the inked block and paper are set down on the board, carefully lay down the packing and slide into the press. To do this without knocking the block and paper, raise the platen as high as it will go to give maximum clearance. Once it is in place, screw down the plate with some force. How much is some force? Somewhere between not enough and too much.

A cover serving as a tympan can be made from a variety of materials. This rubber sheet provides a level of cushioning and protection for the block.

Trial and error is the only way to determine this, but if your impression is too light, try increasing the pressure slightly before upping the level of ink on the roller.

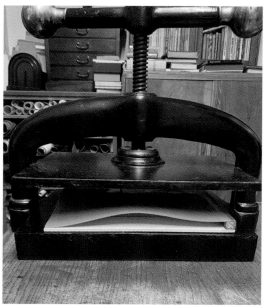

The rubber sheet is hinged to the base board with strong tape.

Care must be taken when sliding the base board with block and paper into the press.

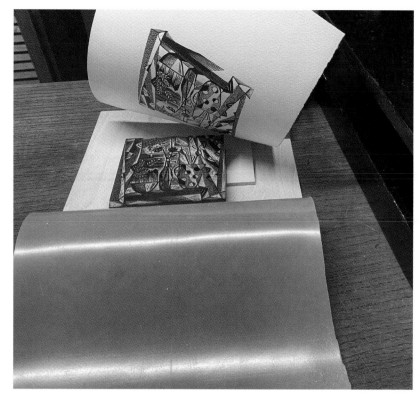

A successful print on medium-weight printing paper.

If your copying press has a plate size of 10 × 8 inches the effective printing size will be less; perhaps a maximum block size of 7 × 5 inches, due to the pressure being concentrated at the centre of the plate.

PRINTING WITH A PLATEN PRESS

The cast iron platen press is an evolution of the fifteenth-century wooden Gutenburg press and its derivations. Gutenburg was from a wine-producing area of Germany and his hand press was modelled on a wine press. This style of press remained the standard until the early nineteenth century, when the industrial revolution saw a burgeoning of cast iron machinery to serve the new era. In the case of the printing industry this resulted in iron printing presses with various lever and toggle mechanisms that were much more efficient

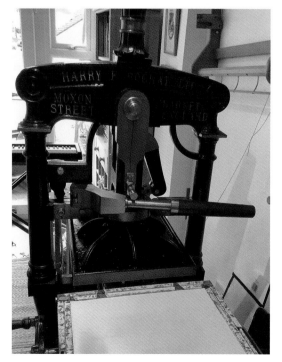

Printing with a platen press. Modern Rochat Albion, courtesy of Sally Hands.

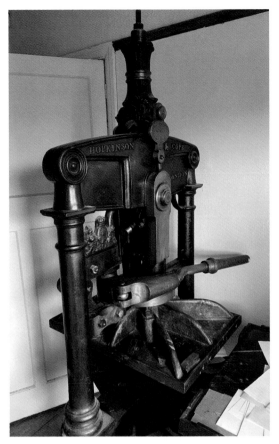

The author's 1890 Albion press, inherited from Monica Poole.

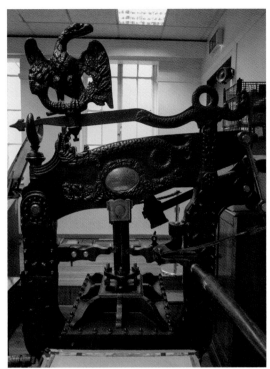

Columbian press with distinctive eagle counterweight.

and stable than their wooden predecessors. The two designs that emerged as the most widely used and manufactured were the Albion and Columbian. The Albion operates with an arrangement of wedges that lower the printing plate or platen when the handle is pulled, and a spring in the crown that lifts the platen when the handle is returned to position. The Columbian lowers the platen by means of levers and a large counterweight in the form of an eagle. This mechanism allows for effortless application of pressure, which some like and others do not. In the unlikely event that you are offered both, try them out and see which you prefer.

If you have access to a press at a print studio or college, the assumption is that it will be correctly set up by the owner or technicians.

Regarding the set-up of your own press, I will assume that everything is in working order (if not, there are contact details for this service at the back of the book), but some fine tuning will almost certainly be needed at some point.

Platen presses are simple machines and those dating back to the early nineteenth century can work as well now as when they were first made. Remember, this is early industrial revolution period engineering, very straightforward with rather generous tolerances.

Setup
Assuming that the platen is level with the bed of the press, the main area of setup is the tympan. The tympan is the hinged, covered lid that is brought down on the inked block and paper before winding under the platen. You can customise the layer between the outer and inner tympans as follows: for most wood engravings with balanced areas of solid black and fine work, use a sheet of firm vinyl drawing

Lowering the tympan on an Albion press.

Tympan packing using green drawing board covering – a good choice for most press work.

board covering. For broader work with larger areas of black or linocuts, a softer packing such as an etching blanket or rubber sheeting would give better results. This is an area for experimentation to discover the right packing for the block you are printing.

Always position your block in the centre of the press bed as the pressure is most concentrated there. I use the following method of block placement and paper positioning: Make an L-shaped piece of plywood (thick card would also do) to locate the block and another L-shaped marker for the paper. This should be made from wood or thicker plywood roughly 18mm thick and have a secondary L-piece of plywood stuck on top. This will allow you to position the paper accurately in relation to the block for each print. It works especially well for colour printing where perfect registration is crucial.

A simple but very efficient way of positioning the block and paper on the bed of the press. I adapted this from the Japanese method of kento registration marks.

Inking the block

Follow the same guidelines for rolling out ink as outlined above. For small- to medium-size blocks I like to hold the block while rolling up with ink, but some engravers will always ink the block on the press bed. For this, the block can be locked in place using printer's furniture or held in place against the L-shaped wooden marker secured to the bed with double-sided tape.

Pass the roller across the block using barely more pressure than the weight of the roller. If you are using a heavy, brass-framed roller then this will be little extra pressure, but more if using a lightweight roller. Roll the entire length of the block twice then tilt the block to the light to ensure that the whole area of the block glistens with ink – a dull patch means you should roll again. Take your piece of printing paper (always smoothest side down) and locate it on the registration L-marker and let it fall carefully onto the block. You can then lightly touch down on the centre of the paper to make it adhere to the block before winding the bed

Traditional method of locking the block securely onto the bed of the press using a chase and furniture.

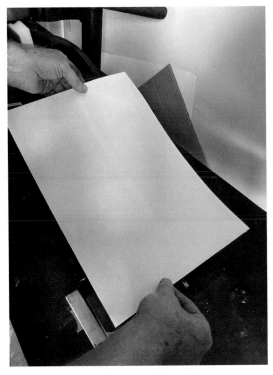

Locating the paper on the registration marker.

Printers hold the pressure for a few seconds, known as the 'printer's kiss'.

under the platen. Now you are ready to pull the handle and make the impression. How much pressure? You need to feel some resistance as the platen is brought down onto the paper and block. Hold for a few seconds (known as a 'printer's kiss'), then ease the handle back to position, wind out the bed and lift the tympan. Lift the paper slowly from one corner and peel the paper from the block. If you are very fortunate you might have a perfect impression at the first attempt. In most cases the first proof will reveal light areas, especially noticeable in the blacks, and these will require attention by way of either underlay or overlay. The latter is known as 'make-ready'.

Underlay

By sticking pieces of thin paper (corresponding in shape and position to the light patches) on the underside of the block, you build up these

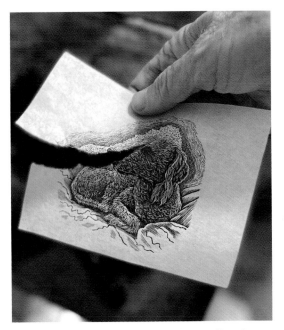

Tearing the edges of both underlay and especially make-ready will avoid the ridge that a cut edge can produce.

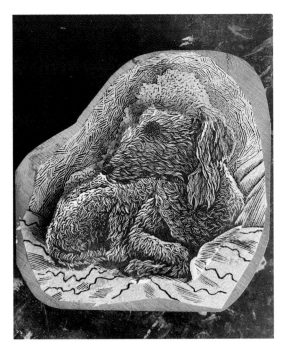

area that was previously getting less pressure. The three torn layers are stepped to give a gradual degree of pressure differential. The first layer covers the largest area, the next a slightly smaller area, and finally the smallest section of torn paper.

A cautionary note on underlay: blocks (usually larger blocks) with a substantial amount of underlay in the central area have been known to crack under pressure. This is rare but can happen due to the 'bulge' created by the underlay, where pressure from the platen can cause the block to crack.

Overlay or make-ready

This is the preferred method used by the best printers of wood engravings, but takes more time and skill than underlay. If your aim is to make a perfectly consistent edition, then I would strongly advise that you take the time needed to build up a careful make-ready on the tympan as follows.

Secure your block on the bed of the press. Attach a piece of paper to the tympan and make a print onto it. This is now the master print, onto which you will stick patches of make-ready in order to build up pressure differentials, which will correct low spots on the print or create emphasis where you require it. This emphasis will also serve to de-emphasise other areas of the print. Before taking another print, hinge a sheet of acetate over the master sheet on the tympan. This layer will smooth out the

areas to increase pressure and arrive at a perfect impression. Once you have decided which sections need more and which sections less pressure, you are ready to start.

First, take a proof on newsprint and stick this to the reverse of the block so that you know exactly where to stick the sections of underlay. I use either spray adhesive or glue stick to do this. Then take another proof on newsprint and cut or tear out the sections of the print that require greater pressure. Stick this to the back of the block and print again. Anything from a single patch of underlay to three or four will rectify the

First layer

Second layer

Third layer

Three pieces of underlay carefully torn from trial proofs. The torn edges prevent a ridge forming.

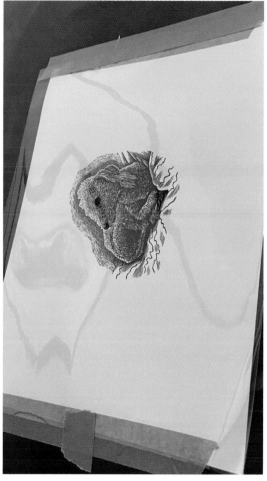

Paper attached to the tympan to receive the make-ready.

Acetate sheet to prevent the make-ready transferring ink to the back of the prints.

patches of make-ready and prevent the ink from the patches transferring to the back of the editioned prints.

You are now ready to create the make-ready. Take a print on a thin paper such as plain newsprint and note the areas that are printing with less pressure. Tear out these areas and carefully stick them in their exact location on the master. Note that you should tear rather than cut out the section, since a torn edge will not create a ridge in the way a cut edge will. Take another print on newsprint and the area in need of correction should be slightly, but noticeably improved. Sometimes a single

layer of newsprint is sufficient, but if not then repeat the process until you have perfectly even pressure across the block. For very subtle degrees of emphasis, tissue paper patches may be all that are needed.

In this example the block did not require any make-ready to compensate for low spots. Instead the aim was to make the shaded areas of the dog stronger and the outer edges and background lighter in tone. All that I needed was to build up the dog-shaped patches to the level that achieved both goals. Three layers of torn newsprint worked perfectly. Here you can see the print before and after adjusts from the

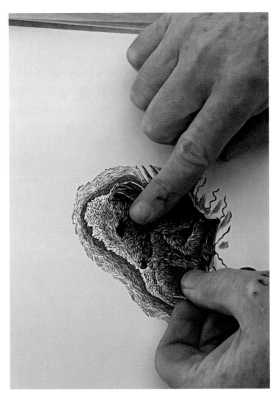

Sticking the torn pieces of make-ready to the master sheet, to create pressure differentials when pressure is applied.

Fine tuning with a layer of tissue or layout paper.

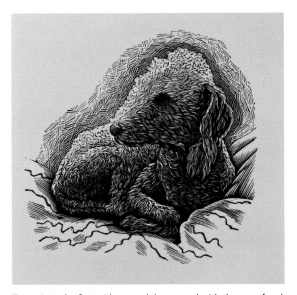

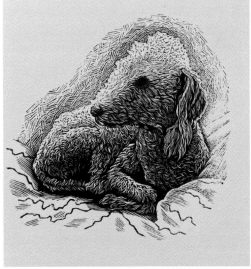

Two prints, the first without and the second with the use of make-ready to give less pressure to the upper section.

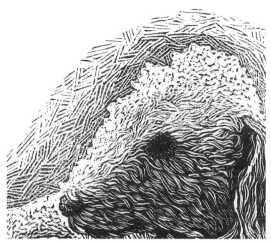
Detail showing the lightened area of the print resulting from make ready.

make-ready. They are subtle, but subtlety is usually all that is required.

The wood engravers' quest for delicate, silvery tones in a medium that, unadjusted, prints the entire block with even pressure, goes back to Thomas Bewick. Bewick developed the practice of contouring, or lowering, areas of his blocks so that parts of the image (often backgrounds) received less ink and less pressure. For a detailed description of Bewick's methods, read Graham Williams' book *Thomas Bewick Engraver & The Performance*

THE GNU.

Engraving by Thomas Bewick. The entire background was lowered before being engraved, to give less pressure and a lighter tone.

of Woodblocks, published by Florin Press. Shades of grey throughout the engraving can be achieved by means of linear shading, cross hatching and stippling, but the problem is that this is often not enough and further work can be done at the printing stage. The most common procedure is the one just described; the other considerations are paper and ink.

STIFF INK

There is no doubt that almost all commercially available inks are not as stiff or highly pigmented as the ones used in the past. For a detailed discussion of this, *see* Graham Williams' book on Bewick's methods (*see* above). It is imperative that wood engravings are printed using a stiff, oil-based ink known as 'letterpress'. The ones commonly used are adequate for most purposes, but if you want to develop the quality of your printing, then try using Gamblin's Tom Huck's Outlaw Black. This is an American ink, though it is available in the UK and is far stiffer than anything else on the market. Because it is so stiff, Outlaw Black will not creep into those delicate areas of engraving, otherwise prone to infill with other inks. However, it takes some time and effort to roll out on the slab and needs much coaxing to be your friend. It is called 'Outlaw' for a reason. If you find Outlaw Black too difficult to handle, then Gerstaeker Stiff Carbon Black is a good alternative.

DRYING PRINTS

If you leave your damp prints to dry without pressing, they will curl. Put the damp prints between dry blotters and this time do not place them in a sealed bin liner, but lay those heavy boards or weights on top overnight. It will then be safe to remove the prints to dry thoroughly and without curling by laying them out individually.

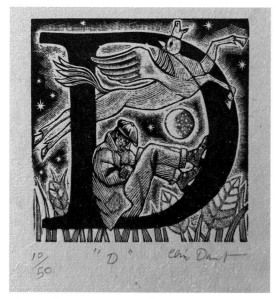

The correct way to sign and number a print.

Scoring the block. Some artists deface the block to prevent further prints being taken.

EDITIONING

There are rules for editioning prints and it is good practice to respect them. The point of a limited edition is that it is limited. It is down to the artist to decide the number of prints in the edition, but between 30 and 150 seem sensible numbers. At the lower end, you might find engravings that are unusually large, requiring greater printing time and costs, resulting in a print that is expensive. In this case the artist might make a return on the work involved with the sale of a smaller edition. Colour engraving, though quite rare, is another instance where smaller editions are appropriate due to significantly more printing time. If the engraving involves four or more colours, the number of 'spoils' (misregistered prints along the way) can be considerable.

From what I have noticed, most editions for small- to medium-sized wood engravings are between 50 and 150. I would suggest that 250 is the upper limit, beyond which the term limited edition becomes somewhat stretched.

I know someone who printed an edition of ten and found, to her surprise, that the engraving was selected for a prestigious exhibition where multiple sales were virtually guaranteed. Sure enough, the edition of ten sold out within days, but she was unable to supply more. Second editions are possible and must be numbered as such with the Roman numeral II next to the edition number.

It is a convention that the artist prints an additional number outside of the edition and marks them A/P. The artist's proof is considered more valuable and in number should be 10 per cent of the edition.

None of these conventions are binding in law, but disregarding them can gain the artist a bad reputation.

There is a practice of defacing the block once the edition is complete as a way of ensuring that no more prints can be taken. This is entirely up to the artist and there is no legal requirement to do so. Many artists prefer to keep the block intact. Above is an example of a defaced block by the late Peter Forster where large scorper cuts have ensured that no more prints are possible. I acquired a number of Peter's blocks after he stopped engraving.

SIGNING

The common practice is to sign, in pencil, to the right and just below the image using a fine pencil, not too dark nor light. The number

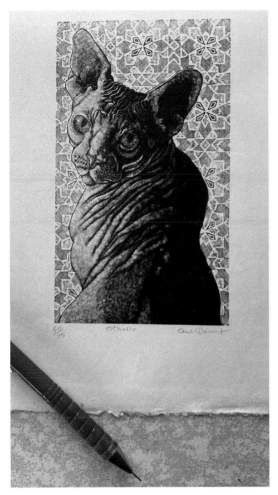

A print showing the conventional way to sign and number an editioned wood engraving. Use a fine pencil – something in the region of 2B – and avoid flourishes or anything that draws attention.

the world of selling, exhibitions and galleries. First, the price the gallery owner sells your print for is not the price you get. Most galleries these days take up to 50 per cent of the selling price, so you need to be aware of their commission before setting your price. If you want £80 for your print, be aware that it will likely be listed at £160. If you think that no one will buy it at this price, then adjust your price. This is a delicate procedure and something the majority of artists struggle with. Price too low and your work will not be respected, too high and it will not sell.

In these days of websites and online selling, alongside conventional art galleries and exhibitions, it is important that your prices align. Your website selling price needs to be the same as the gallery price, otherwise you may upset a buyer as well as the gallery owner. Information travels fast.

Once you have achieved a certain level of competence, the decision to show your work presents itself and this can be a daunting situation in which good advice can be helpful. Joining the Society of Wood Engravers or The Wood Engravers Network is a good idea for many reasons and there you will find many experienced artists who will gladly advise you in matters such as selling your work. These societies exist to support and further wood engraving and members will be glad to look at your work and advise you. I am inclined to price in such a way that I sell more prints at a modest price rather than fewer at a high price.

within the edition is marked to the left and expressed thus – 1/75. If you wish to include the print title, then this should be written in the centre. Since most engravings are relatively small and delicately worked, restraint should be exercised here – bold, swashbuckling signatures in 6B pencil are not appropriate.

PRICING

This is entirely down to the artist, but there are things to consider once you launch yourself into

FRAMING

Using a good picture framer is money well spent. I know from experience that cheap framing is a false economy. A good framer not only has the technical skills and equipment, but also good judgement and taste and will offer you sound advice. Just having the latest digital mount cutter and mitre machine is not enough. I recently had a polite dispute with a framer

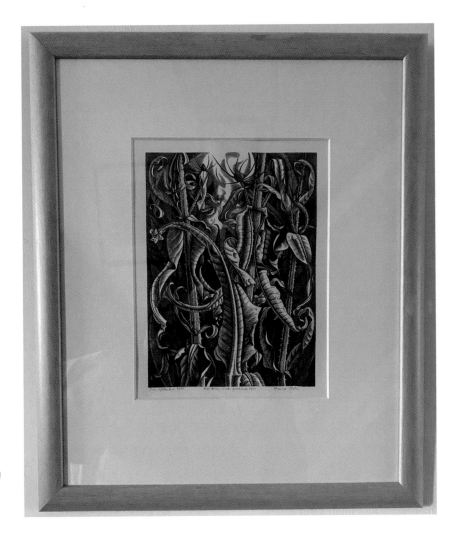

Plain frames are a safe choice when exhibiting work and generally work well with wood engravings.

about the optical centre of a window mount not being the same as the measured centre. This is basic framing knowledge, but he lacked it. Although frame choice is a matter of taste, a neutral frame is advisable for exhibiting work.

It is also vital that your framer uses acid-free materials, including the tape used to secure the print. Once you find a good framer that you trust, stick with them.

PRINT STORAGE

Old-fashioned plan chests are good, but the draw size is usually huge, so you might want to place your prints in folders within the drawers. Make sure they are acid free, whether acetate or card.

If you usually state editions of, say 100, you might print only 30 to begin with. Should you be lucky enough to sell 30, then print another 30, and so on. This way you will not end up with large numbers of stored prints that may or may not sell. However you store your editioned prints, having a good labelling system is helpful so that you know exactly where to find any given set of prints.

I have a notebook in which I note which prints have sold, when they sold and who bought them.

CONCLUSION

I hope it is now apparent why I chose to call this book *The Art and Craft of Wood Engraving*. Perhaps you have felt inspired by some of the engravings featured here, and not put off by the demands of the craft required. A good engraving is the product of imagination as well as care in the making. No book or teacher can give you the gift of imagination but can certainly help to draw it out, as well as pass on the tried and tested processes that constitute craft. Who knows where inspiration comes from – great artists and poets often speak of their creations coming from outside of their consciousness and regard themselves as mere conduits. I can think of several of my own engravings that came into my mind more or less fully formed and out of the blue, while others arrive half-formed and need to gestate for a while. This is wonderful when it happens and I urge you not to ignore the muse, her inspirations easily evaporate if ignored.

After the idea comes the hard labour of getting it from mind to paper. In my experience these are the birth pangs and place the greatest demands on my creative abilities. It is here that the picture in the imagination must come down to earth and fit into block shape drawn on the page with all the requirements of composition and tone that only you can determine. A teacher or someone you know with a good eye can offer suggestions if you are unsure about an aspect of the design, but always trust your own judgement, even after you have factored in someone else's comments.

I am never happier than when I am engraving – the tortuous composing complete and I draw upon my repertoire of mark-making skills, acquired over many years, knowing that nothing will go badly wrong once the preliminaries are in place. Following the engraving stage comes printing, which is weighted more towards craft. I urge you not to regard printing as that tiresome bit at the end, as I have seen too many decent engravings let down by poor printing technique.

Once you have several engravings under your belt, it is possible that the beginnings of a style will emerge – but you should not feel it has to. In my case this took many years, and my back catalogue is chameleon-like in variety. There is no reason why you should not work in one manner then another, according to your inclination.

In conclusion, I would like to encourage you to draw from life as much as possible and only use photographs as a reference point if you need them. By drawing directly from the three-dimensional world you will gain an understanding of form, space and light in a way that is impossible with only a photograph as your source.

Remember the words of Peter Forster: '... wood engraving is as spontaneous as making a soufflé'.

GLOSSARY

Albion Press The most commonly used press for wood engravings. First made in the 1820s and being manufactured once again by Harry Rochat.

Boxwood The traditional wood used in wood engraving. Derived from the Latin *Buxus* or *Buxaceae.*

Brayer American word for inking roller.

Bruising Damage to an edge caused by the underside of the tool pressing into the wood.

Bullsticker A tool with an oval-shaped cross section. A variation on the spitsticker with a more bulbous profile.

Burin A generic and less common term for engraving tools.

Burnisher A small wooden tool used to hand-burnish a print in the absence of a press.

Calendared paper This is a process of smoothing the surface of a paper by pressing it between highly polished rollers. A calendared paper works well with finely detailed engravings.

Chisel tool A small engravers' chisel for chamfering edges and removing ridges on cleared areas.

Clearing Removing wood where white areas are required.

Columbian Press Similar to the Albion Press, but uses a large counterweight in the form of an eagle.

Crosshatching A set of parallel lines engraved on top of another set, at an angle, to create a secondary tone.

Edition A set number of prints from the block, which are signed and numbered.

Graver A generic term for engraving tools, but also specifically for those with a diamond or lozenge profile.

Halo A white zone around an object, which isolates it from the background.

Hatching An area of tone created with a set of close parallel lines, usually diagonal.

Holly An occasionally used wood with excellent properties.

Honing Sharpening on a fine stone to maintain a polished edge.

Intaglio Opposite of relief printmaking, in which the image comes from the lines and not the surface (etching for example).

Lemonwood Sometimes called Castello Box-wood. An excellent substitute for traditional boxwood. Not the lemon tree, but called lemonwood because the leaves have a citrus smell when rubbed.

Lowering The practice of scraping down areas of the block before engraving them, creating different levels in order to

produce light, silvery tones. Though not invented by Thomas Bewick, he mastered this technique.

Make-ready A method of overlaying on the tympan of a press to create pressure differentials.
Maple Commonly used engraving wood in the USA.
Multiple tool Sometimes called a liner tool. Made to engrave several lines at once.

Nipping press Sometimes called a bookbinder's or copying press. A screw press, usually in cast iron and budget alternative to an Albion or Columbian press.

Overlay *See* Make-ready.

Pearwood Used for both woodcut and wood engraving. Softer than boxwood and pink in colour. Pleasant to engrave.
Platen press Printing presses such as the Albion and Columbian, in which pressure is transferred to the block by means of a plate.

Relief printmaking The family of printmaking to which wood engraving belongs. It also includes woodcut and linocut. This is the method whereby the print is taken from the relief surface of the block. The opposite of

Intaglio, in which the image comes from the incised or etched lines, as found in etching.

Sandbag Firm, sand-filled leather cushion used to support the block, for ease of rotation and movement.
Scorper Engraving tool with either a round or square edge, used for broad lines and clearing.
Spitsticker Engraving tool with a boat-shaped profile, used by most engravers as a general purpose tool.
Stippling Dots placed at varying proximity to create tone and texture.

Tint tool Engraving tool with straight sides, especially useful for straight lines of even width. A versatile tool, since it also works well with tight curves and stippling.
Type high Engraving blocks are made to the same height as a stick of moveable type in order to print together.

Underlay Pieces of paper placed under the block on the bed of the press to correct uneven pressure.

Waterleaf Waterleaf paper is unsized, making it soft and highly absorbent (kitchen towels and blotting paper are unsized). These papers are usually good for printing engravings (such as Arches 88) but should not be dampened.

SUPPLIERS AND SOCIETIES

UK SUPPLIERS

AMR Logan Press
Co-Operative Yard, Crown Works,
74 Victoria St, Irthlingborough,
Wellingborough NN9 5RG
Tel: 01933 681961
www.amrloganpress.co.uk
Supplier of second-hand presses, press
renovation and removal service.

Chris Daunt
1 Monkridge Gardens, Dunston,
Gateshead NE11 9XE
www.chrisdaunt.com
Wood engraving blocks, endgrain engraving
blocks in various woods, made to exact
size. Also, burnishers, tool wraps and tool
sharpening service. Engraving tuition.

Deerness Tools
Tel: 07964 150908
www.deerness55.co.uk
Email: deerness55@me.com
Beautiful wood-engraving tools with hand-
turned hardwood handles. Tool shortening and
sharpening service.

Handprinted
22 Arun Business Park, Bognor
Regis PO22 9SX
Tel: 01243 696789
www.handprinted.co.uk
General printmaking supplies. Sells a good
range of beautiful Japanese Awagami papers.

Harry F. Rochat Ltd
15A Moxon St, Barnet EN5 5TS
Tel: 020 8449 0023
www.harryrochat.com
Best known as a maker of fine etching
presses, Rochat now makes Albion presses
based on original models but using modern
close-tolerance engineering. Also suppliers of
printmaking rollers.

Hawthorn Printmaker Supplies
The Workshop, Moor Lane, Murton, York,
North Yorkshire
Tel: 01904 488602
www.hawthornprintmaker.com
General printmaking supplies. Good range of
rollers and inks. Suppliers of Lincoln Wash
cleaner, highly recommended for cleaning up
oil-based inks.

Intaglio Printmaker
9 Playhouse Ct, London SE1 0AT
Tel: 0207 928 2633
www.intaglioprintmaker.com
General printmaking supplies in London. Good
mail order service.

Jackson's Art Supplies
1 Farleigh Pl, London N16 7SX
Tel: 020 7254 0077
www.jacksonsart.com
Vast range of art supplies as well as printmaking equipment.

John Purcell Paper
15 Rumsey Rd, London SW9 0TR
Tel: 020 7737 5199
www.johnpurcell.net
Paper specialists with vast stocks of printmaking papers. Knowledgeable staff.

T. N. Lawrence & Son Ltd
36 Kingsthorpe Road Hove, East
Sussex BN3 5HR
Tel: 01273 260 260
Email: artbox@lawrence.co.uk
Long-established printmaking supply shop, also general art supplies and tool shapening. Mail order service.

US SUPPLIERS

McClain's Printmaking Supplies
PO Box 230759
Tigard, OR 97281-0759
www.imcclains.com
Specialising in equipment for Japanese woodcut, but also general print supplies.

Jim Reynolds
Milwaukee, Wisconsin
Tel: 00-1-414-771-1377
jmreynolds@wi.rr.com
Custom maple endgrain blocks.

Moore Wood Type
Gahanna, Ohio
Tel: 00-1-614-507-921

www.moorewoodtype.com
scott@moorewoodtype.com
Maple, holly, pear blocks.

E.C. Lyons Company
3646 White Plains Rd,
Bronx, New York 10467
Tel: 718 515-5361
Fax: 718 515-7790
email: sales@eclyons.com
E.C. Lyons and Muller engraving tools.

UK SOCIETIES

The Society of Wood Engravers (SWE)
www.societyofwoodengravers.co.uk
Founded in 1920 for the promotion of wood engraving. The society welcomes subscribers and promotes the work of elected members. Issues a quarterly journal entitled *Multiples* and a monthly newsletter. Also, a touring annual exhibition showing the best of contemporary wood engraving. Engravings can be purchased through the website.

US SOCIETIES

Wood Engravers Network
998 Grover Blaydes Rd
Bagdad, KY 40003
https://woodengravers.org/
The Wood Engravers' Network (WEN) is a non-profit arts organisation dedicated to the advancement of wood engraving arts and committed to furthering public recognition and appreciation of the art of wood engraving, its practice and history as art, illustration, graphic design, and printing. Its goals are to provide educational and exhibition opportunities and increased public access to this historic process.

BOOKS

There are many how to do it books on wood engraving. I have only listed the ones I have read and found useful. This is a 'desert island disc' selection and reflects my own tastes and range of reading around the subject.

HOW TO DO IT BOOKS

Brett, Simon *Wood Engraving – How to do it* (A & C Black, London, 2010)

An indispensable handbook. Simon writes as elegantly as he engraves.

Farleigh, John *Graven Image* (MacMillan & Co Ltd, London, 1940)

Part autobiography and part practical.

Leighton, Clair *Wood-Engraving and Woodcuts* (The Studio Ltd, 1932)

From the golden age of wood engraving, when the medium was coming of age.

HISTORICAL

Bewick, Thomas *A General History of Quadrupeds*

Bewick, Thomas *A History of British Birds* (two volumes)

Even in Bewick's lifetime these volumes were prized. If you buy the late eighteenth- and early nineteenth-century editions printed from the original blocks you will have a wonderful collection of Bewick engravings. They are also very readable as natural history texts.

Bohn, Henry G. *A Treatise on Wood Engraving* (Chatto and Jackson, 1838)

A detailed history of woodblock printmaking by W. A. Chatto followed by an invaluable section on the practice of wood engraving by John Jackson, a pupil of Thomas Bewick. Still in print, but worth buying a nineteenth-century copy.

Cole, Alphaeus and Margaret *Timothy Cole Wood Engraver* (The Merrymount Press, 1935)

A highly readable life of the great American facsimile engraver by his son Alphaeus. Alphaeus was the oldest living person just before he died aged 112 in 1988.

Williams, Graham *Thomas Bewick Engraver & The Performance of Woodblocks* (Florin Press, 2021)

A very important and long-awaited study of Bewick's engraving methods and materials and the printing of his blocks.

BOOKS WITH WOOD ENGRAVINGS

Since the origins of wood engraving are so closely bound up with illustration, it would be impossible to suggest a list of titles that did not run into many pages. Instead of such a list, here is one of my favourites:

Bates, H.E., with 73 engravings on wood by Parker, Agnes Miller *Through the Woods – The English Woodland – April to April* (Victor Gollancz, London, 1936)

An exquisitely beautiful book to own. Early editions are letterpress.

INDEX

First published in 2023 by
The Crowood Press Ltd
Ramsbury, Marlborough
Wiltshire SN8 2HR

enquiries@crowood.com
www.crowood.com

This impression 2024

© Chris Daunt 2023

British Library Cataloguing-in-
Publication Data
A catalogue record for this book is available
from the British Library.

ISBN 978 0 7198 4309 9

Typeset by Envisage IT

Cover design by Sergey Tsvetkov

Printed and bound in India by Nutech
Print Services - India

ACKNOWLEDGEMENTS

I would like to thank all the engravers who
agreed to show their work in this book. I could
have included many more had space allowed.

Simon Brett
Harry Brockway
Andrew Davidson
Tony Drehfal
Sally Hands
Louise Hayward
Weimin He
Pete Lawrence
Miriam Magregor
Hilary Paynter
Howard Phipps
David Robertson
Richard Wagener